IMAGES
of America

NAPA VALLEY'S
JEWISH HERITAGE

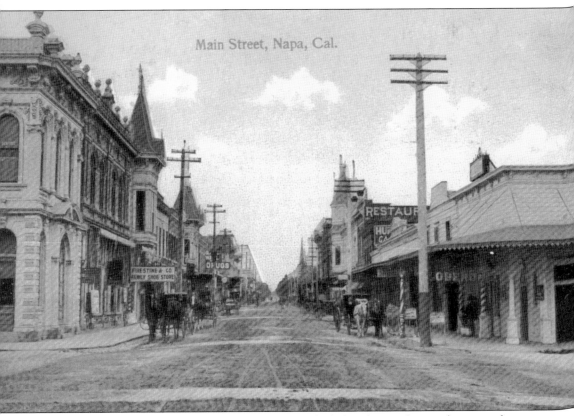

Main Street, Napa, Cal.

By the 1900s, it was clear that the Jewish community had played a significant role in transforming an unsettled frontier outpost into a thriving center of commerce and culture. Virtually every town in Napa Valley was influenced by noteworthy contributions from Jewish merchants and entrepreneurs whose shops and sense of fairness made small-town life manageable. The postcard shows Main Street in Napa around 1910. (Courtesy of the Henry Michalski Postcard Collection.)

ON THE COVER: Customers of D. Hirschler and Company celebrate the fruit of the vine (see page 33). (Courtesy of The Magnes Collection of Jewish Art and Life, Bancroft Library, University of California, Berkeley.)

IMAGES
of America

NAPA VALLEY'S JEWISH HERITAGE

Henry Michalski and Donna Mendelsohn for
the Jewish Historical Society of Napa Valley

ARCADIA
PUBLISHING

Copyright © 2012 by Henry Michalski and Donna Mendelsohn for the Jewish Historical
 Society of Napa Valley
ISBN 978-0-7385-8898-8

Published by Arcadia Publishing
Charleston, South Carolina

Printed in the United States of America

Library of Congress Control Number: 2011930974

For all general information, please contact Arcadia Publishing:
Telephone 843-853-2070
Fax 843-853-0044
E-mail sales@arcadiapublishing.com
For customer service and orders:
Toll-Free 1-888-313-2665

Visit us on the Internet at www.arcadiapublishing.com

*To our dear friend Louise Packard, of blessed
memory, whose philanthropy, dedication, and love of
community and Judaism inspired this book.*

CONTENTS

Acknowledgments

Heartfelt thanks go to Arcadia editor Coleen Balent and production coordinator David Mandel, who understood what we were trying to accomplish and allowed us the latitude to achieve it.

The Jewish Historical Society of Napa Valley's dedicated board of directors—Zoe Kahn, Lynn Michalski, Lauren Chevlen, and Phyllis Kleid—deserve grateful appreciation, particularly Lynn for organizing and scanning the images and her willingness to do whatever was necessary.

The authors sincerely thank Robyn Brode Orsini for copyediting, Leza Lowitz for editorial assistance, and Daniel Eisner for Hebrew guidance.

Documentation groundwork was laid by Lin Weber in *Under the Vine and the Fig Tree* and by Sue Morris, curator of the Jews of Napa Valley exhibit at the Napa Valley Museum.

Claire Erks's generosity in providing photographs and oral histories from Lottie Rosenberg and Julian Weidler were invaluable. Allison Moore of the California Historical Society and Robert Zerkowitz of the Wine Institute of California provided seldom-seen images. Wells Fargo Bank librarian Marianne Babel, Patricia Keates of the Society of California Pioneers, and David Kernberger and Dona Bonick furnished excellent photographs.

Thanks go to research director of the St. Helena Historical Society Mariam Hansen, Kara Brunzell and Charlotte Watters of Napa County Landmarks, and Jules Evans-White of the Napa County Historical Society. Kristie Sheppard of the Napa Valley Museum graciously allowed us access to the museum's archives. Harriet Rochlin became a wonderful mentor at the research libraries at the University of California, Los Angeles.

Historian Fred Rosenbaum lent support, as did Dalia Taft of the Orange County Jewish Historical Society.

Wine historians Charles L. Sullivan and Gail Unzelman were gracious with their time and knowledge. Scott Harvey, the Carpenter family, and Fulton Mather astounded us with photographs of St. Helena's early Jewish synagogue.

Lastly, Donna Mendelsohn acknowledges her grandmother Ida Baumel for passing on narratives of Jewish life in America and for instilling in her the importance of preserving Jewish history.

Congregation Beth Sholom and the Jewish Historical Society of Napa Valley have been shortened to CBS and JHSNV, respectively, in the courtesy lines for the photographs.

We give our sincerest apologies for any errors in this book.

INTRODUCTION

Long before Napa Valley became a destination site, a place that Congressman Mike Thompson calls "America's most loved valley," it was a dusty rural community with few permanent structures and no public services. Napa City, as it was then called, was laid out by a handful of early pioneers in 1848 but flourished only after gold was discovered in the Sierra foothills.

That same year, the United States acquired California and the world rushed in. Hundreds of young Jewish men, hailing mostly from central Europe, crossed the punishing, mosquito-infested Isthmus of Panama and then traveled by steamer up the coast to San Francisco. A few chose the more dangerous route around the treacherous currents of Cape Horn at the tip of South America.

Jews were among the first passengers to disembark in San Francisco. Like everyone else, they were eager to find a better life in a place where "all men are created equal." California's gold country became a kaleidoscopic array of humanity, where people were measured by their word and character rather than their place of birth or origin.

Between 1848 and 1860, hundreds of Jewish entrepreneurs, a high percentage of the global newcomers, came to San Francisco and the gold country. A few made their way to the bucolic Napa Valley, an oak-studded basin nestled between two mountain ridges that embraced the Napa River. For the miners, it was an ideal place for shipping and commerce and a natural outpost and shelter from the inhospitable mountains during winter. Unlike the prospectors, many of the Jews who came to California arrived not to pan for the precious metal but to sell the necessities of everyday life to those who did. The first Jewish settlers peddled their wares from carts, tents, wagons, and small boats moored along the river, trading in gold dust.

Many of the early Jewish families became prominent merchants. In Napa, they could do what they could not dream of achieving in Europe, joining non-Jewish fraternities such as the Order of the Odd Fellows or the Masons. One was a founding member of the local Native Sons of the Golden West.

Though pioneering Jews could open businesses and join gentile clubs and lodges; they never forgot their roots. From 1880 to 1910, a private Victorian farmhouse on Fulton Lane in St. Helena housed the first synagogue in Napa County, which about 40 Jewish families joined. Unencumbered by the prejudices of their native lands, Jewish businessmen were largely a carefree lot, enlivening the newspapers with their colorful advertisements. They were characters and storytellers who contributed greatly to the social and economic development of the valley. By the beginning of the Civil War, Napa was an important commercial center.

In his 1909 classic *Silverado Squatters*, Robert Louis Stevenson writes of the Jews that "few people have done my heart more good; they seemed so thoroughly entitled to happiness, and to enjoy it in so large a measure and so free from after-thought; almost they persuaded me to be a Jew." A century later, Lin Weber wrote in *Under the Vine and the Fig Tree*, "Virtually all the communities in the Napa Valley began with significant contributions from Jewish merchants whose shops made village life possible."

The 1920s and 1930s marked a drastic decline in the Jewish population of Napa County. The national attitude of isolationism and creeping xenophobia made the county an unwelcome place. The Ku Klux Klan was on the rise, holding several rallies. Real estate agreements included a persuasive clause that land could only be sold to "whites." Blacks, Chinese, Mexicans, and Jews were not welcome. During Prohibition, many farmers were forced to replace vines with grains and prunes. Jewish businessmen, for the most part, moved their families and dry and fancy goods businesses to more urban areas. A few Jews, however, such as the Levinsons, Galewskys, and Goodmans, remained in Napa Valley.

By the 1950s, a resurgence of Jewish families made Napa Valley their home. The arrival of George Rosenberg, who came to Napa to marry his sweetheart Lottie Rosenthal, changed everything. When Lottie refused to travel to San Francisco for the High Holy Days with their infant daughter, George had few options but to gather together the "Napa Jewish Group" and conduct services in Joe Lazarus's auto supply store, private homes, or the downtown firehouse. The group borrowed a Torah from Congregation B'nai Israel in Vallejo. In 1953, under Rosenberg's leadership, 13 families established Congregation Beth Sholom.

Rabbi Leo Trepp, the last rabbi to have a congregation in Germany, fled his native land in the late 1930s and taught at Napa Valley College. In 1955, Napa decided to sell the decaying chamber of commerce building to the Jewish community for $1 on the condition that it be moved. The congregants raised $2,500 and moved the hulking structure to its current location in Old Town. The founders invited the dignified Dr. Trepp to lead services at the newly formed synagogue.

In 1963, the old building was fully remodeled and dedicated and to this day continues to serve about 150 Jewish families as a full-service synagogue that boasts a thriving religious and Hebrew school program, swimming pool, fully stocked library, monthly Shorashim preschool program, the Soul Sisters Book Club, and more.

Independent Jewish groups have formed, such as the Jewish Historical Society of Napa Valley (www.JHSNV.org), a nonprofit, volunteer-based organization that provides the community with a living legacy conveying the richness and diversity of the valley's Jewish heritage. The Jewish Community of Napa Valley, under the capable direction of Dr. Lee Block, is dedicated to raising funds anonymously—the highest form of *tzdakah*—that enables the endowment of worthy arts and cultural endeavors. There is also a strong Chabad presence in the valley.

The Jewish connection to wine reaches back more than 5,000 years. The Torah clearly points out that wine is a sign of God's abundant blessings and that we are to enjoy the "gladdening of the heart" that it brings. Tasting the fruit of the vine is an integral part of every Shabbat service and plays an essential role at every Jewish ceremony, rite, ritual, and celebration.

Jewish vintners were among the first to discover Napa Valley's perfect convergence of elements necessary for growing and making fine wines. Early Jewish winemakers include Leopold and Julia Lazarus, who planted 16 acres of wine grapes in Yountville in 1869, and Friedrich Herman "Fritz" Rosenbaum, who founded Johannaberg Winery in 1878. Later, Hanns Kornell, a Holocaust survivor, paved the way for other vintners with his famous Champagne Cellars. Many more vintners followed. In modern times, we honor the Brounsteins (Diamond Creek Winery) and the Finkelsteins (Judd's Hill Winery), among others. More than 40 Jewish winemaker families in Napa County are mentioned in this book.

We hope that you will enjoy learning about Napa Valley's Jewish heritage, from the Gold Rush to Chabad's "soul rush," as much as we have enjoyed the process of uncovering little-known facts and photographs that document the long Jewish legacy of contributions to the magnificent Napa Valley.

One

STRANGERS IN AN UNSETTLED LAND
JEWS WANDER IN (1848–1900)

האָרֶץ, אֲשֶׁר עָבַרְנוּ בָה לָתוּר אֹתָהּ – טוֹבָה הָאָרֶץ, מְאֹד
מְאֹד. אִם-חָפֵץ בָּנוּ, יְיָ – וְהֵבִיא אֹתָנוּ אֶל-הָאָרֶץ הַזֹּאת,
וּנְתָנָהּ לָנוּ: אֶרֶץ, אֲשֶׁר-הוּא זָבַת חָלָב וּדְבָשׁ.

The land that we traversed and scouted is an exceedingly good land. If the Lord is pleased with us, He will bring us into that land that flows with milk and honey, and give it to us.

—Numbers 14:7–8

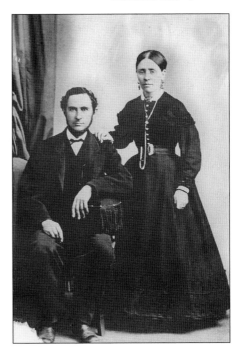

From 1849 to 1860, hundreds of Jewish entrepreneurs came to San Francisco and the gold country, drawn by stories of fortunes to be had. Freedman Levinson, a Prussian, and his wife, Dora (pictured), were attracted to the small Gold Rush settlement of Napa because of its mild climate. Settling in Napa with their daughter Annie, the birth of five more children caused a population boom. (Courtesy of Claire Erks.)

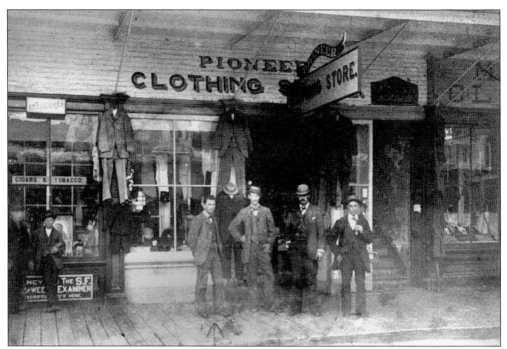

Most of Napa's newcomers conducted their business from carts, tents, wagons, and small boats stationed along the Napa River. The Levinsons set up a small general store on Main Street that offered sundries, as well as implements and clothing for miners. The Levinsons accepted gold dust in exchange for merchandise. Freedman Levinson, on the far right, kept a caged canary outside the store to attract customers. (Courtesy of Claire Erks.)

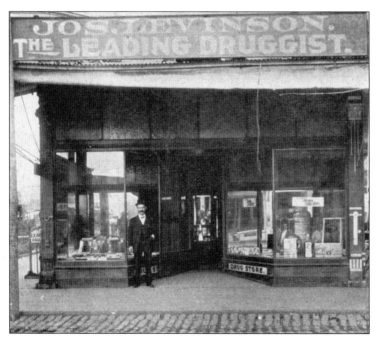

Freedman's son, Joseph, became a pharmacist and opened a drugstore on the southwest corner of First and Main Streets in Napa, where it remained until the 1970s. Since Napa had no hospitals or clinics, Levinson procured an old x-ray machine, the only one in Napa County, so that doctors could bring patients to look at their fractures. He poses in front of the store in 1908. (Courtesy of Claire Erks.)

1596 Fire Department, Napa, California.

Son Charlie Levinson went into the ready-to-wear clothing business and was a founding member and lifelong secretary of the Native Sons of the Golden West chapter. What he enjoyed most, however, was serving as a volunteer firefighter with the Unity Volunteers Hose Company. After the San Francisco earthquake and fire of 1906, Unity joined forces with rival hose companies to form a permanent, city-run fire department. (Courtesy of the Henry Michalski Postcard Collection.)

It was Levinson who arranged to use a room located above the fire department for Napa's small Jewish community to conduct services for the High Holy Days of Rosh Hashanah and Yom Kippur, as well as other observances of the Jewish faith. Pictured here is an autograph book, preserved by Charlie's sister, Sarah Levinson, in which he pens his thoughts in 1892. (Courtesy of Claire Erks.)

Dear Sarah.

May sweet and flowery be thy way,
And skies all bright above thee,
And many a happy coming day,
To thee and those that love thee.

Your Brother
Charlie.

Napa Oct 5th 1882.

In 1879, Joseph Galewsky was born to Simon and Rebecca, who had established a general store on Main Street in St. Helena in 1858. When Rebecca died in 1904, Rabbi Kaplan of San Francisco conducted the funeral. Her obituary in the *St. Helena Star* stated, "We have never known any person more kindly disposed to all than she." The entire family is buried in the St. Helena Cemetery. (Courtesy of the Napa Valley Museum.)

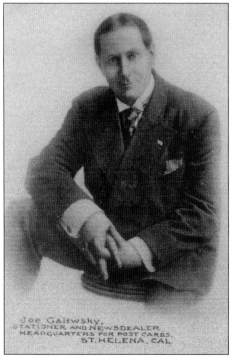

Galewsky was a prankster as a young man and a politician as an adult. The fashionable, lifelong bachelor was appointed postmaster of St. Helena; he ran the post office from his popular stationery and bookstore. He was active in the Native Sons of the Golden West and the Masons, and he was a charter member of the St. Helena Rotary Club. (Courtesy of the Napa Valley Museum.)

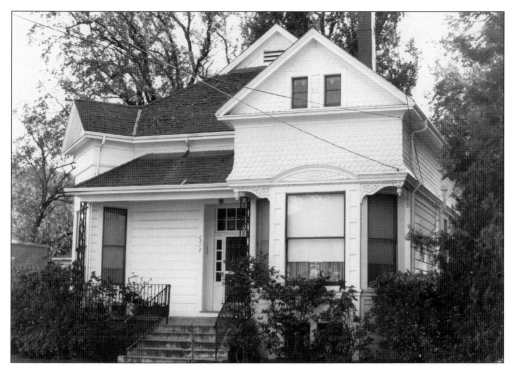

In about 1860, the J. Frank family was the first Jewish family to settle in Calistoga. Their home, a modest Victorian cottage built in the 1870s, now houses the Sharpsteen Museum offices at 1317 Washington Street. The couple lived there with their two sons, Mose and Fred. They opened a mercantile store in the Odd Fellows building, specializing in dry goods and food staples. (Courtesy of Napa County Landmarks.)

David L. Haas was born in Germany in 1842 and came to America via Panama in 1859 with brothers Martin and Solomon. He married Francis Squibb and had two children, Leopold and Munson. Haas became director of the Bank of Napa, which boasted $250,000 in capital in 1872. The brothers had stores in Napa (right), St. Helena, and Calistoga. (Courtesy of the Napa Valley Museum.)

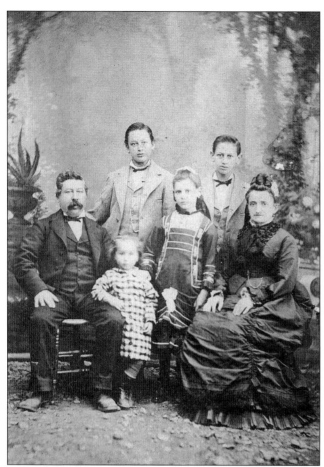

Leopold Lazarus left France in 1848 at the age of 21 and eventually headed to the mountains to try his hand at mining gold. His adventuresome spirit brought him to St. Helena. He married Julia Straus, a native of Alsace, in 1863. The photograph shows the Lazarus family; from left to right are (first row) Leopold, Sylvain, Leontine Rose, and Julia; (second row) Alfred A. and Leon A. (Courtesy of Wells Fargo Bank.)

Lazarus's gregarious nature and swift mind landed him the prestigious job of agent for Wells Fargo & Company, which served the town of St. Helena as post office, express service, and later, a bank. He was elected city treasurer and served for five terms. Pictured here, a train arrives at the Napa train depot in 1890. A Wells Fargo & Company express wagon awaits packages for local delivery. (Courtesy of Wells Fargo Bank.)

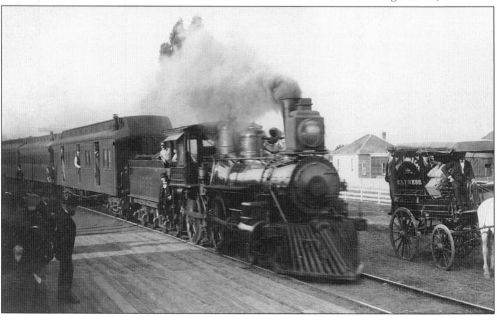

Trained as a sculptor in Germany, Henry Getleson came to Calistoga in 1866, building the town's first general store at Washington and Lincoln Streets and stocking the shelves with dry goods, boots, hardware, and groceries. The store also handled the mail. He took in Morris Friedberg as a partner in 1871 but left the partnership after a year. In 1874, Getleson become a charter member of the Free and Accepted Masons. (Courtesy of the St. Helena Public Library.)

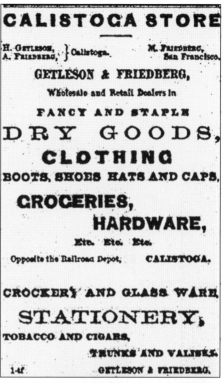

Friedberg kept the old store and installed the first private telephone line in Calistoga. His modest home later became Piner's Hot Springs and is now the Roman Spa. Robert Lewis Stevenson referred to Friedberg as "Kelmar, a Jew Boy" in *The Silverado Squatters* about his sojourn in Calistoga and the nearby area. (Courtesy of Napa County Landmarks.)

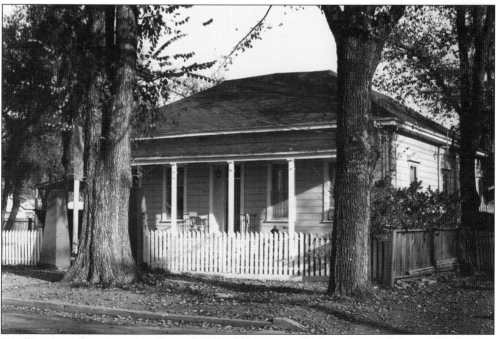

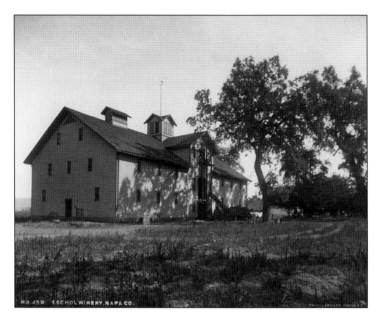

Although their Jewish heritage is uncertain, the banking brothers George and James Goodman founded Eschol (Hebrew for "cluster of grapes") Winery in 1886. The winery's cabernet sauvignon won first-place honors in 1888, and during Prohibition, it was rumored to be a bootleg site. The cellar was restored in 1968 by the Trefethen family. (Courtesy of the Charles B. Turrill Collection, Society of California Pioneers.)

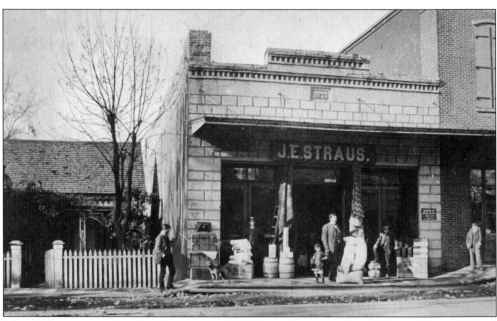

Jules E. Straus arrived in San Francisco in 1865 from Alsace via New Orleans. He established himself in St. Helena and worked for Lazarus and Levy's general store before moving around the western states and returning with his wife, Janet (Levy). He started a store at 123 Main Street. He was a member of the Odd Fellows Lodge and the Ancient Order of United Workmen. He left town in 1881. (Courtesy of the St. Helena Historical Society.)

The Victorian farmhouse shown here, located at 830 Fulton Lane in St. Helena, served as a synagogue from 1880 to 1910. Serving the spiritual needs of the 40 Jewish families, who were mostly merchants living in St. Helena, the rabbi or lay leaders are lost to history, but it is known that the basement was a kosher slaughtering facility. Today, the house serves as the offices of a private winery. (Courtesy of Scott Harvey and the Carpenter family.)

The David Fulton Winery, across the street from the Fulton Lane synagogue, is the oldest winery in St. Helena and the oldest, continuously owned, family vineyard in California. Edgar Washington Mather (on wagon), Fulton's grandfather, was friendly with the synagogue's members and possibly supplied grapes for the synagogue's kosher wines. (Courtesy of Fulton Mather.)

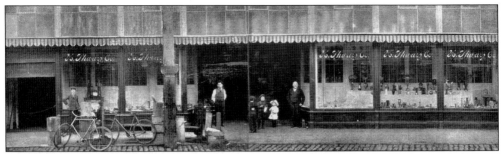

Herman Shwarz, one of five brothers, was born in Germany in 1848. He came to Napa in 1871 and married Lizzie Fleishman. That same year he opened a hardware store that, by 1906, was the largest hardware store in the county. The house the Shwarzes gave as a wedding present to their daughter is now the La Belle Epoque Inn. Herman and Lizzie eventually turned the store operations over to their three sons, William, David, and Max. (Courtesy of the Napa Valley Museum.)

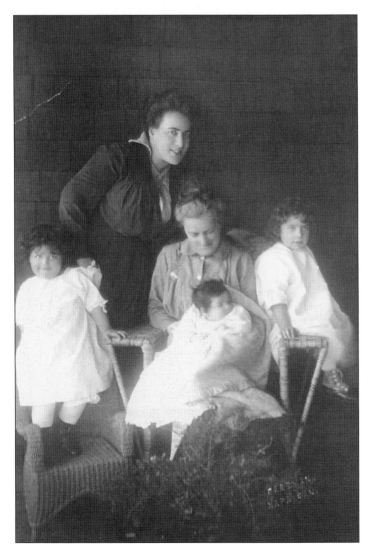

Max Shwarz married Jeanette Manasse, who bore him three daughters. She died when the children were quite young. He then married Jeanette Marks, who raised the girls. From left to right are Minnie, grandmother Elizabeth Shwarz holding Helen, and Henrietta. Jeanette Manasse Shwarz is standing in back of them. (Courtesy of Robert Larson.)

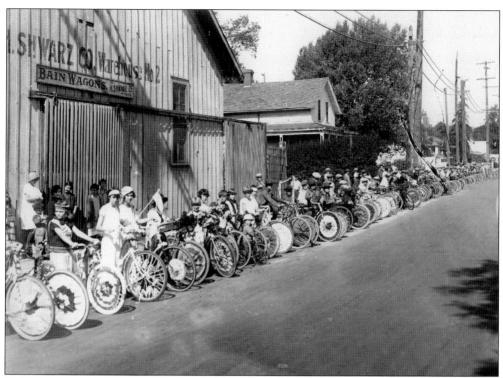

Bicycle parades were popular in the 1920s. At the corner of Coombs and Clay Streets in Napa, looking north, kids on their decorated bikes eagerly await the beginning of the May Day procession beside Herman Shwarz's Warehouse No. 2, which likely housed large items sold in the Main Street hardware store, such as wagons, farm implements, tools, and stoves. (Courtesy of David Kernberger.)

Girlhood friends are portrayed possibly enjoying an important social event. Merchants' daughters mingled with their non-Jewish friends while attending dances and operettas at the Napa Valley Opera House or taking tea at the Goodman Library. Clara Levinson is seated in front. Standing from left to right are Gussie Kather, Bertha Engle, Amelia Kather, Lillie Kather, Minnie Shwarz, and Sarah Levinson. (Courtesy of Claire Erks.)

Emanuel Manasse, one of Napa's most respected citizens, was born in Germany in 1842. After mastering the tanner's trade, he came to America in 1864 with his wife, Anna Marie Amelia (Hellwig), arriving in San Francisco via Nicaragua. In 1871, Manasse became superintendent of Napa's Sawyer Tannery. He was a prominent Republican, an Odd Fellow, and a Mason with the rank of Knight Templar. (Courtesy of Analee Manasse Chambless.)

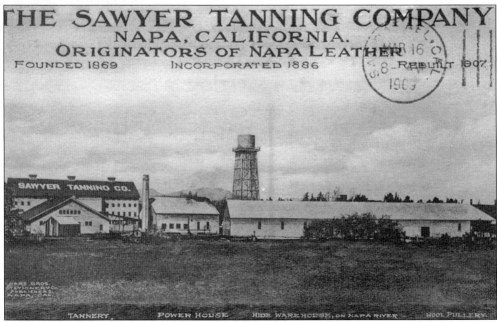

In 1870, after noticing that local butchers were discarding sheep pelts with the wool still on them, French A. Sawyer started a "wool-pullery" plant, the Sawyer Tannery, on the banks of the Napa River. He hired some Chinese laborers and employed Emanuel Manasse as his superintendent. Manasse discovered a new method of tanning sheepskin and buckskin to make it waterproof, known as the Nap-A-Tan process. (Courtesy of the Henry Michalski Postcard Collection.)

Pictured here is the inside of the Manasse mansion, located at 443 Brown Street in Napa, along with Emanuel Manasse and his six children. From left to right are (first row, seated) Lena, Emanuel, and wife Amelia; (second row, standing) Anna, Henry, Amelia, Edward, and August. Both Henry and Edward worked with their father at the tannery. (Courtesy of Analee Manasse Chambless.)

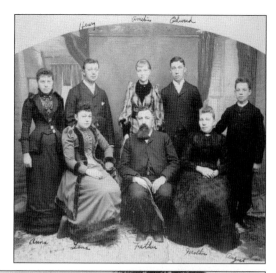

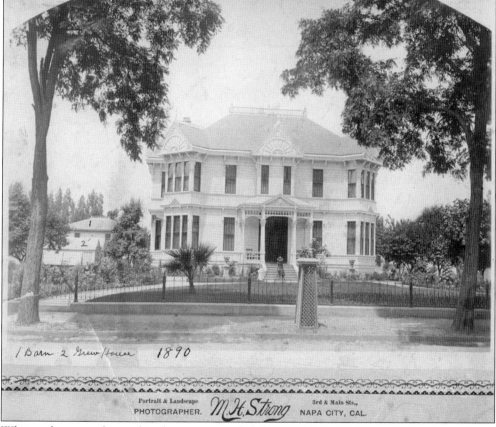

White columns and sprawling lawns surrounded the 12,000-square-foot mansion designed and built by famed architect W.H. Corlett. The building became a duplex after Emanuel Manasse died and remained so until the Depression, when it was converted into a rooming house. In the 1940s, it became a six-unit apartment house. It was remodeled in 1990 as the Blue Violet Bed and Breakfast and became the White House Inn and Spa in 2008. (Courtesy of Analee Manasse Chambless.)

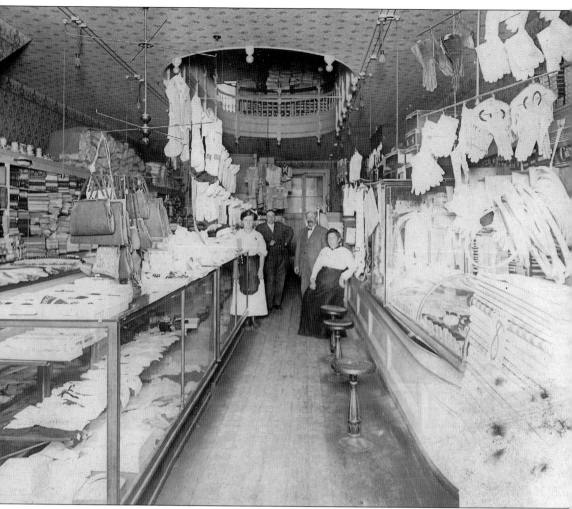

Joseph Schwartz was born in Bohemia, Austria. By 1900, he and his wife, Adelhide (Vogel), had opened a dry goods store called City of Paris on Napa's Main Street, the inside shown here in 1890. With the Shwarz Hardware Store nearby, people began calling the entire street near the Opera House the "Schwartz Block." The Schwartzes were so significant socially that the home they built in 1890 at the corner of Oak and Franklin Streets made news in the local paper. It was a fine Queen Anne/East Lake Victorian designed by popular architect Luther Turton. It boasted an attached conservatory, four bedrooms upstairs, and indoor plumbing—a rarity at that time. The Napa newspapers were fascinated with the comings and goings of this prominent family. Adelhide hailed from important New York kin and had siblings in San Francisco. Joseph and Adelhide celebrated their 50th anniversary in 1928. Joseph died in 1932, and Adelhide died two years later in San Francisco's Mt. Zion Hospital. (Courtesy of Harvey Schwartz.)

The Schwartzes' son, David, a native Napan, was born in 1879 and married the beautiful Belle. As a wedding gift, Joseph built an elegant duplex for the newlyweds next door to the family home. David rented the bottom flat to important people traveling through Napa, including Theodore Bell, three-time candidate for governor of California. David was associated with his parents' store and active in many fraternal affairs. (Courtesy of Harvey Schwartz.)

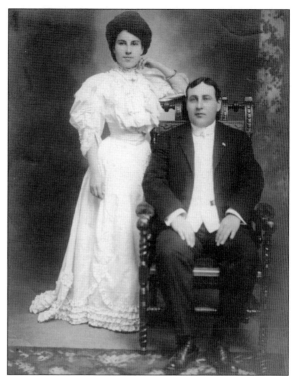

David and Belle Schwartz were the proud parents of Irving Schwartz (who became a well-known doctor) and the grandparents of Harvey Schwartz, a labor historian. The photograph of three-year-old Irving can be seen in the permanent exhibit about the valley's Jewish heritage at the Napa Valley Museum, located on the grounds of the historic Veterans Home of California in Yountville. (Courtesy of Harvey Schwartz.)

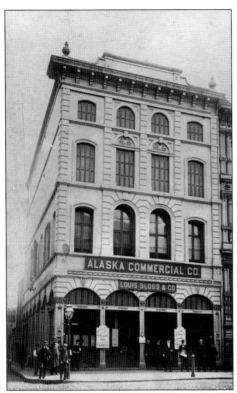

Finnish sea captain Gustave Niebaum, plying the frigid waters off Alaska during its purchase from Russia in 1867, arrived in San Francisco with a fortune in seal and otter skins. After selling the skins, he became partners with Louis Sloss and Lewis Gerstle, part of San Francisco's Jewish elite. They bought the Russian-American Trading Company and renamed it the Alaska Commercial Company, headquartered in San Francisco. (Courtesy of the California Historical Society.)

Niebaum, left, is shown with Sloss and Gerstle in the Alaska Commercial Company's office, discussing the business of selling luxurious and exotic furs, a delight for the wealthy and thought to be a necessity in cold weather. When asked if he was Jewish, Niebaum often replied that he was; however, most historians debate this. (Courtesy of the California Historical Society.)

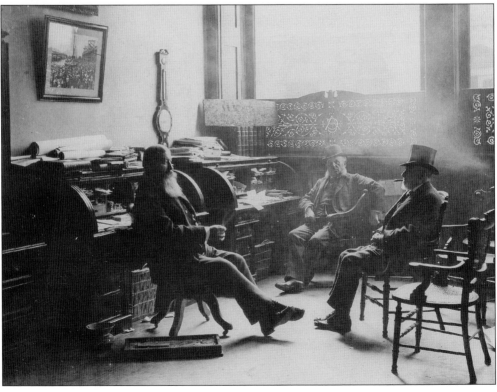

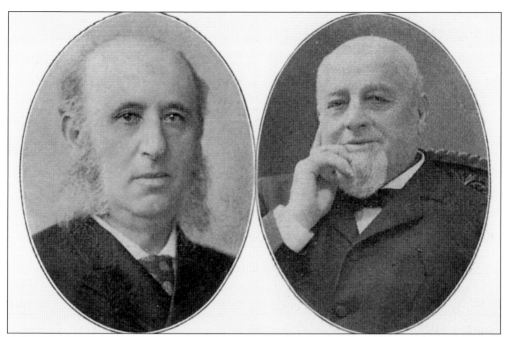

Gerstle (left) and Sloss, natives of Bavaria, Germany, immigrated to Kentucky and then Sacramento as partners of a mercantile house. Both were influential members of San Francisco's prestigious Temple Emanuel. They eventually made retired Civil War general John F. Miller president and spokesman for their company. General Miller built a pillared mansion in Napa named La Vergne, today the Silverado Country Club. (Photograph by Ferrand Studio, from *Western Jewry*.)

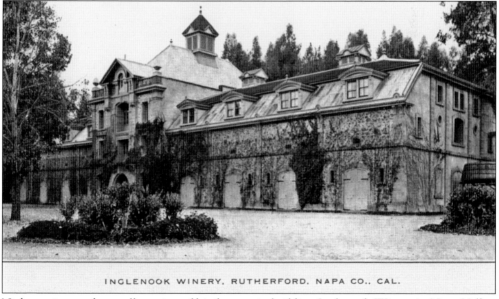

INGLENOOK WINERY, RUTHERFORD, NAPA CO., CAL.

Niebaum invested a small portion of his fortune in building Inglenook Winery in Napa Valley. In 1882, he crushed his first vintage, about 80,000 gallons. He was the first to recognize that the soil itself, not just the winemaker's "magic," was a major factor in producing premium-quality wines. Today, Inglenook is owned by the Francis Ford Coppola family. (Courtesy of the Henry Michalski Postcard Collection.)

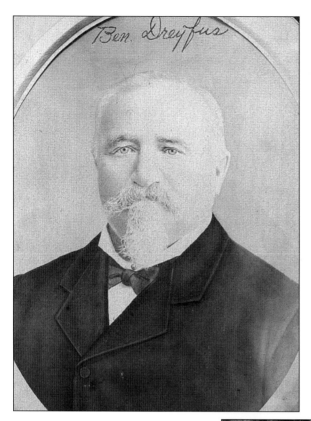

When Benjamin Dreyfus moved to Anaheim, California, from Bavaria, Germany, in 1858, he became the first Jewish resident of Orange County. He was one of the original members of the Los Angeles Vineyard Society, which was created to buy, cultivate, and promote wines. He and grocer Emanuel Goldstein purchased Barth Vineyards in 1880, changing its name to Mount Pisgah (meaning "mountain summit") Vineyard. Their B. Dreyfus Company distributed Napa wine. (Courtesy of the Anaheim Public Library.)

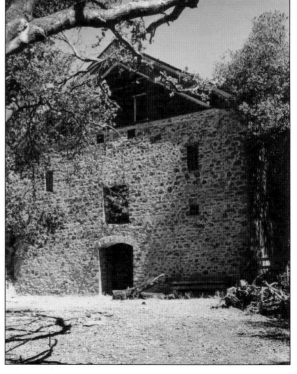

Mount Pisgah took its name from the Book of Deuteronomy. When Benjamin Dreyfus died in 1886, Mount Pisgah became the property of Emanuel Goldstein, who renamed it the Goldstein Ranch. In 1938, Goldstein's heirs sold the property to Louis M. Martini, who renamed the vineyard Monte Rosso, reflective of its iron-rich soils. (Courtesy of the Wine Institute of California.)

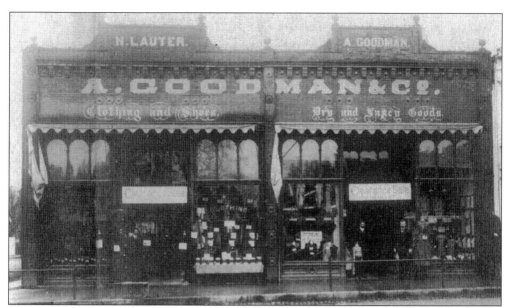

Abraham Goodman, born in Hungary in 1851, arrived in Cincinnati at the age of 25, where he met Cecilia Rosenthal. They married and had three children: Julius, Jacob, and Tessie. After moving to St. Helena in 1879, the Goodmans opened a mercantile store on Main Street. In 1882, Goodman went on trial for testing the law that forced stores to be closed on Sunday. The jury acquitted him after deliberating for ten minutes. In 1887, Nathan Lauter became Goodman's partner. (Courtesy of David Teideman.)

Lauter was a tall, dapper man. He and his wife, Antoinette, operated a clothing and shoe store on Main Street in St. Helena, which was a boom town boasting a population of about 1,700. Three years after forming the partnership with Goodman, the new stone building on Main Street was completed. (Courtesy of Marjorie Haber Zellerbach.)

Friedrich Herman "Fritz" Rosenbaum, born in 1833, arrived in America from his native Germany at age 17. He peddled wares on horseback in the Shasta/Marysville area and volunteered to fight in the Modoc Indian War. At age 27, after earning enough money to go back to Germany, he married the beautiful Johanna, age 18. The couple moved to San Francisco with connections to manufacturers of high-quality stained glass, fine mirrors, and more. (Courtesy of Alexandra Haslip.)

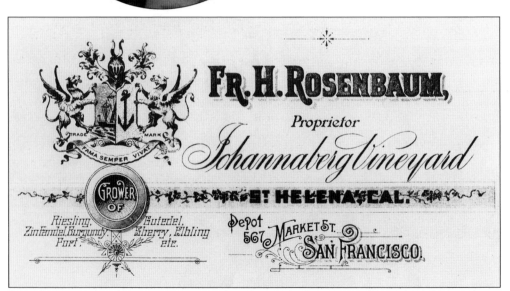

Rosenbaum prospered in San Francisco, where he supplied a growing demand for glass products. Finding the serenity and climate of St. Helena irresistible, Friedrich and Johanna purchased more than 80 acres near Beringer Vineyards. Rosenbaum planted grapes in 1879, and his first vintage, represented by the wine label shown here, yielded over 3,500 gallons of juice. (Courtesy of Alexandra Haslip.)

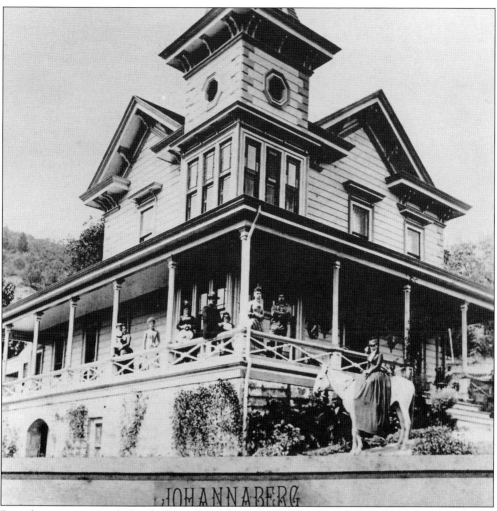

JOHANNABERG

Rosenbaum constructed a four-bedroom house he named Johannaberg for his wife and growing family. It was a stylish house befitting a man of his stature. The house was finished in 1878; four years later, Rosenbaum added a fashionable Queen Anne turret and wraparound porch. Located at 2867 St. Helena Highway, the Victorian Gothic residence on the western hillside holds a commanding view of northern Napa Valley. In 1962, the estate was sold and resumed making wine under the name Spring Mountain. Thirteen years later, it was resold and remodeled, selling premium wines under its current name, St. Clement Vineyards. The Rosenbaums had six children: Johanna, Fred, August, Bertie, Marianne, and Emma. Bertie, who was almost killed by a jealous suitor in 1892, is seen in the photograph on the horse. The Rosenbaum family is buried in the St. Helena Cemetery. (Courtesy of Alexandra Haslip.)

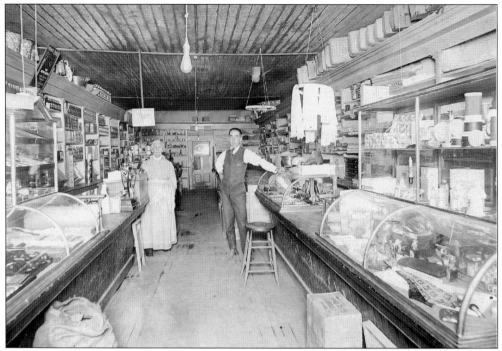

Felix Grauss opened a store in Calistoga that offered paper products, ice cream, candy, and baked goods. He was the baker and his wife did the selling, serving up a cookie with every purchase. Two of their children had a little wagon and a dog. When there was a bakery delivery, they would harness the dog to the wagon and away they would go, to the amusement of the locals. Here, the Grausses pose inside their store. (Courtesy of the Napa County Historical Society.)

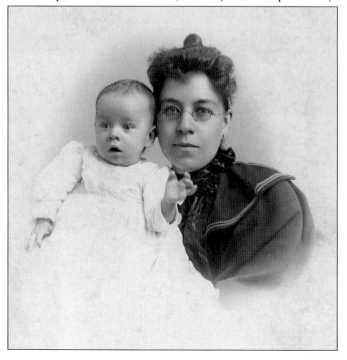

Grauss and his wife, Mattie, were the proud parents of six children: Charles, Margaret, Muriel, Lowell, Bernice, and Felix Jr. Here, Mattie is seen holding baby Charles, the oldest child, born about 1895. (Courtesy of the Napa County Historical Society.)

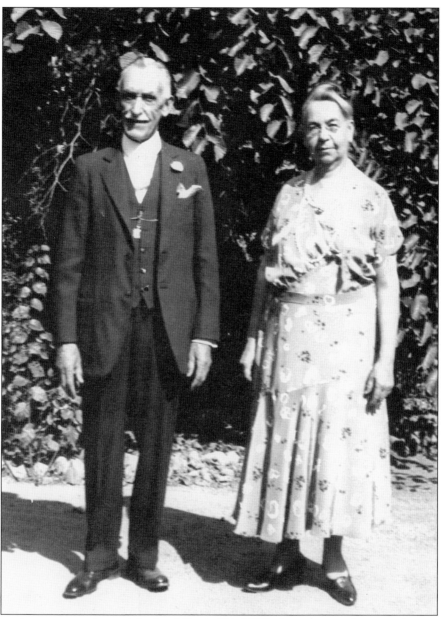

As America was preparing to join the Allies in World War I, newspapers became ultrapatriotic, and the public was encouraged to be on the lookout for anyone acting un-American. A pro-German, Republican political appointee, Felix Grauss ran the local post office out of his store for 16 years. When power shifted to the Democrats, he was demoted to assistant postmaster. He made comments critical of America's war involvement, calling the Liberty Loan drive that helped finance the war "worthless," an especially damning opinion since war bonds were sold at the post office. A mob of about 20 men, calling themselves the Committee of Safety, grabbed Felix and forced him to kiss the American flag. Two weeks later, again repeating his Liberty Loan criticism, he was fired and removed from his other civic duties. He was indicted by a grand jury for violating the Espionage Act and later arrested. Here are Felix and Mattie late in life. (Courtesy of the Napa County Historical Society.)

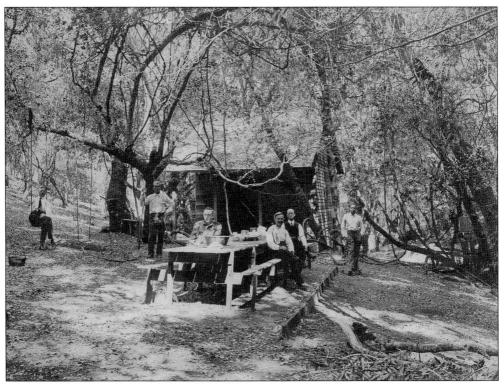

Members of the Gentlemen's Outing Club are shown at a site near today's St. Helena Highway. Those men, without other transportation, could have accessed the campsite by taking the train, which made a scheduled stop at Trubody Station. Seated at the table enjoying the fresh air are friends Al Fromelt Sr. (left) and Joseph Levinson. (Courtesy of Claire Erks.)

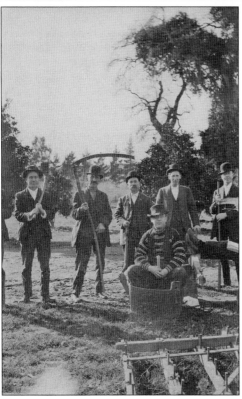

The Gentlemen's Outing Club was a private social club frequented by men who enjoyed camping, boating, and other outdoor activities. Charles Levinson (second from left) is seen holding a scythe that was perhaps used to clear the campsite. (Courtesy of Claire Erks.)

Two

MERCHANTS, ENTREPRENEURS, AND GO-GETTERS
A TIME OF CHANGE (1900–1940)

אדחלא אכרעיך זבינך זבין. כל מילי זבין ותחרט, בר
מחמרא, דזבין ולא תחרט.

Sell your wares while the sand is still on your feet. Everything you may sell and regret, except wine, which you can sell without regrets.

—The Talmud

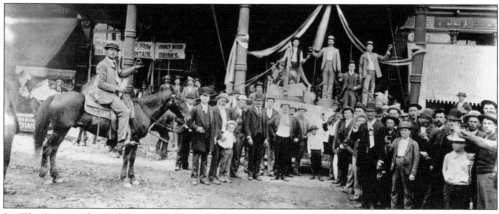

In *The Jews in the California Gold Rush*, Robert Levinson states, "A well-known showman of that time remarked [that] he could easily gauge the prosperity of a mining town by the number of Jewish shopkeepers it maintained and the size of its Chinatown." The Napa Valley towns, although not located directly in gold country, had plenty of both. Here, David Hirschler and his friends celebrate with a hearty *l'chaim*, a toast "to life." (Courtesy of The Magnes Collection of Jewish Art and Life, Bancroft Library, University of California, Berkeley.)

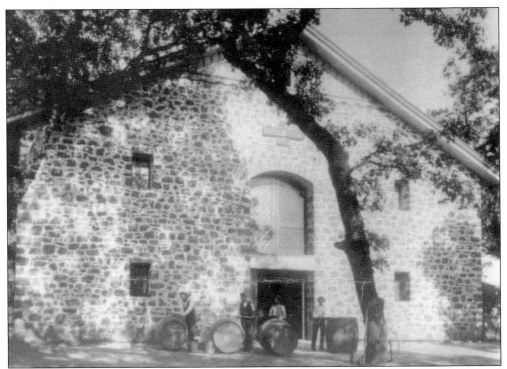

David Hirschler, proprietor of Meridan Kentucky Whiskey and Summit Vineyard, maintained offices in San Francisco. This c. 1890 photograph shows what may have housed his Chinese-built, gravity-flow winery, which served a stagecoach route. Today, Pride Mountain Vineyard, situated at the crest of the Mayacamas Mountain range, produces world-renowned wines. (Courtesy of Carolyn Pride.)

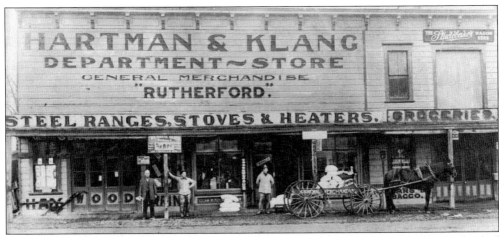

This c. 1913 photograph shows the Hartman & Klang storefront and delivery wagon in Rutherford (population 22 in 1905), about four miles south of St. Helena. When Siegfried Hartman's daughter, Victoria, married Leon Klang, a family business was born. The early "department store" included a barbershop, post office, butcher shop, and general merchandise. The store operated from 1912 to 1926. (Courtesy of The Magnes Collection of Jewish Art and Life, Bancroft Library, University of California, Berkeley.)

Dr. Adolph Kahn and his wife, Edith, moved from San Francisco to Napa in 1900, where they resided until 1910. A prominent physician and surgeon, Dr. Kahn also served as county physician and city councilman. The Kahns had two sons, Robert and Horton. Dr. Kahn's most important legacy is the magnificent residence he built at 1910 First Street. (Courtesy of the St. Helena Public Library.)

4957 Residences, Napa, California On the Road of a Thousand Wonders

The Kahns commissioned noted Napa architect Luther M. Turton to design their home in 1905. It is an excellent example of the popular Colonial Revival and Shingle style. Burt Voorhees purchased the home in 1910. For a short time, the Hanna Boys Center used the house, followed by flamboyant socialite Joan Hitchcock. Today, Jim and Carol Beasley operate a popular inn there, the Beasley House. (Courtesy of Napa County Landmarks.)

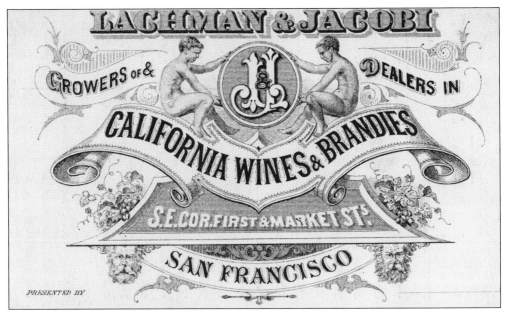

Abe Lachman started in the wine business as a bookkeeper for his half-brother, Samuel. In 1876, Abe started his own cellars, along with Frederick J. Jacobi, who had recently arrived from Germany. During the 1880s, Lachman and Jacobi built a 2.5-million-gallon wine facility in San Francisco, one of California's largest independent wine merchants. (Courtesy of the California Historical Society.)

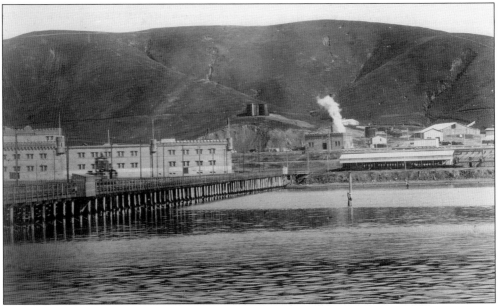

Jewish financiers Isaias Hellman and Benjamin Dreyfus bankrolled the California Wine Association (CWA), a cartel of major wine merchants. By 1902, CWA controlled the wine production of more than 50 wineries, many of which were in Napa Valley. The 1906 earthquake destroyed the San Francisco facility; the following year, a mammoth wine-making facility was constructed at Point Molate overlooking San Pablo Bay. Winehaven boasted a 50-ton crusher, automated pumping, and a blending system. (Courtesy of the Wine Institute of California.)

At one point, CWA controlled about 84 percent of the state's total wine production. After Prohibition, it produced sacramental and medicinal wines. Nonalcoholic grape juice (CALWA) became part of the Winehaven operation in 1908 and was popular during Prohibition. Heavily advertised as a business opportunity for wineries, grape juice was sold as an alternative to wine. (Courtesy of the San Francisco Public Library.)

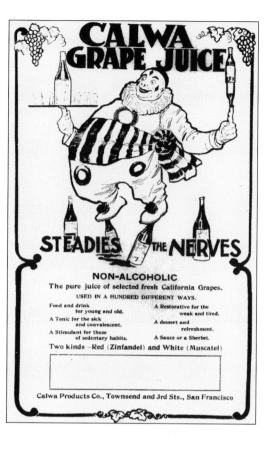

CALWA GRAPE JUICE

STEADIES THE NERVES

NON-ALCOHOLIC
The pure juice of selected fresh California Grapes.
USED IN A HUNDRED DIFFERENT WAYS.

Food and drink for young and old.	A Restorative for the weak and tired.
A Tonic for the sick and convalescent.	A dessert and refreshment.
A Stimulant for those of sedentary habits.	A Sauce or a Sherbet.

Two kinds—Red (Zinfandel) and White (Muscatel)

Calwa Products Co., Townsend and 3rd Sts., San Francisco

Henry Lachman, son of Samuel Lachman, became the general manager of his father's business, which was known for its production of sherries and brandies. After Samuel's death in 1892, Henry became one of the first shareholders of the CWA, investing $30,000. He was considered to have one of the finest palates in the state and was in charge of all CWA wines, responsible for their grading, classification, and blending. (Photograph by Ferrand Studio, from *Western Jewry.*)

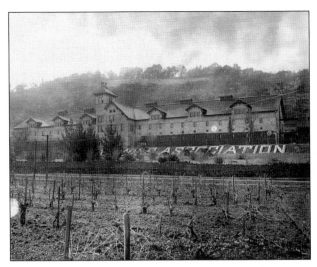

Henry Lachman, a California representative on the international wine-judging panel at San Francisco's Pan-Pacific Exposition, introduced the procedure of segregating varietal wines and the policy of "letting the wines themselves determine the price." Through his efforts, Greystone Cellars (now the Culinary Institute of America at Greystone) in St. Helena, with a storage capacity of 3.5 million gallons, was acquired and considered the jewel in the CWA crown. (Courtesy of Henry Michalski Postcard Collection.)

Chance Worth Johnson lived in Yountville from 1886 to 1965. As a mail carrier for the Yountville post office, he was friendly with the many Jewish postmasters of the day. His granddaughter, Kathleen Conrey, converted to Judaism and is active in Napa Valley's Jewish community. She served on the board of trustees of Congregation Beth Sholom, as well as Hadassah. (Courtesy of Kathleen Conrey.)

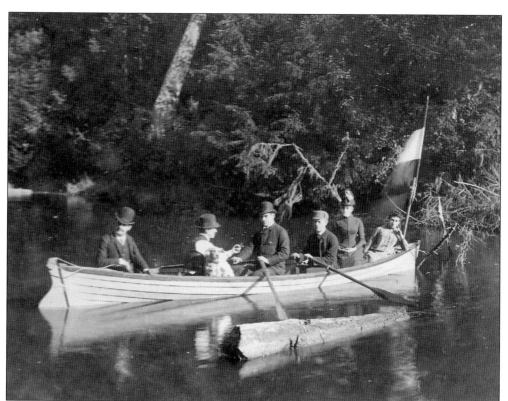

Barney Levy was born in London to a family of cigar manufacturers. He came to San Francisco to make his fortune, where he met Clara, the youngest of Freedman Levinson's daughters. They married and set up a small tobacco shop in Napa next to the clothing store owned by Clara's brother, Charlie. Levy is at far left in the boat; Clara is second from right. (Courtesy of Claire Erks.)

Levy was also a songwriter. He penned a composition for the 1915 Pan-Pacific International Exposition celebrating the opening of the Panama Canal called "Land of the Poppy," which was rejected by John Philip Sousa because he was unknown as a composer. Although Levy never enjoyed financial prosperity or fame, he did not lack for joie de vivre; he performed his own songs in San Francisco cabarets. (Courtesy of Claire Erks.)

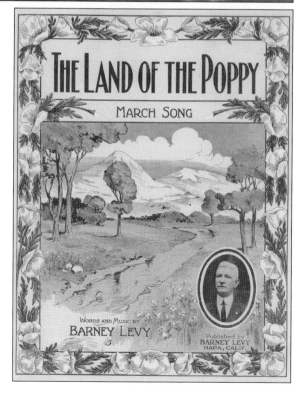

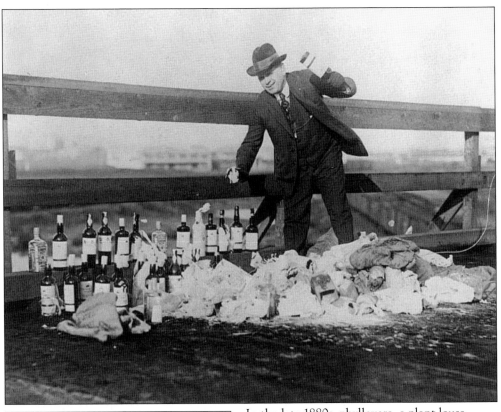

In the late 1880s, phylloxera, a plant louse, destroyed over 10,000 acres of vineyards. Then, Prohibition (1920–1933) made wine production illegal. Federal agents destroyed thousands of gallons of wine, as shown here. Some Napa farmers replanted their vineyards with wheat or prune orchards. It would take decades to convince a whiskey-drinking nation about the joys of sipping wine. (Courtesy of the University of Washington, Library Digital Collection.)

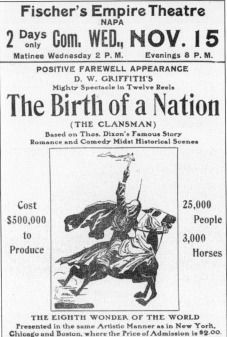

The Hayes Theatre, later the Empire Theatre, was purchased by Sam Gordon in 1914. The epic *Birth of a Nation* was shown at the Empire and reflected the racism gripping the nation. The Ku Klux Klan was on the march in Napa Valley in the 1920s, so many Napa Jews, feeling unwelcome, took their dry and fancy goods and fled to more urban areas. (Courtesy of the Napa County Historical Society.)

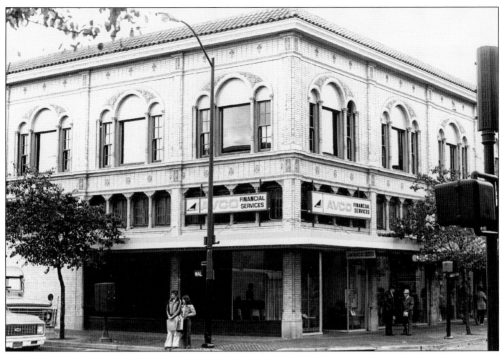

Gordon emigrated from Russia, arriving in the United States in 1905. After building several theaters in San Francisco, he moved to Napa in the 1920s, where he was a successful theater owner and commercial developer. The Gordon Building (above), at First and Coombs Streets, reflects the Spanish Colonial Revival and Spanish Renaissance styles. Gordon had one son, Samuel, with his wife, Louise. (Courtesy of the Napa County Historical Society.)

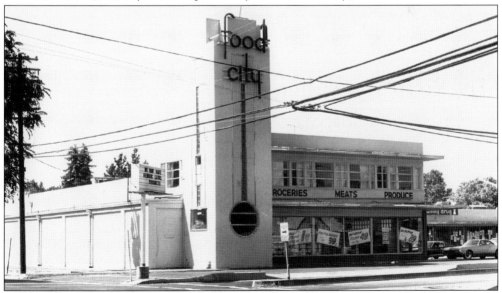

Gordon played an important role in the development of downtown Napa. In the late 1930s, he developed Food City, Napa's first drive-in strip mall, at 1805 Old Sonoma Road. The streamlined Art Moderne style is the most striking in the tower, with its round glass window and neon sign. (Courtesy of Napa County Landmarks.)

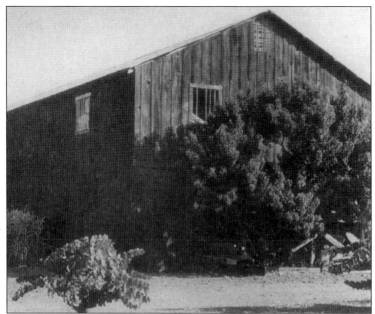

In April 1934, the Metropolitan Fruit Distillery Company opened for business with a front-page article in the *St. Helena Star* describing the operation at the former Bornhorst Winery. The newspaper extolled the distribution of several hundred sample bottles of Muscat brandy as gifts to the citizens of St. Helena. (Courtesy of the St. Helena Public Library.)

Thus it was that Abraham Schorr, Philip Levin, and Samuel Finkelstein purchased tons of sundried prunes (pictured) and raisins for the manufacture of Mount Helena brandy. Assisted by a crew of 25 local men, the brandy received many favorable comments. However, an altercation soon took place that involved shoving between Finkelstein's wife, Anna, and Schorr. Within months, the business, which began on such a high note, was dissolved by court order and its assets sold. (Courtesy of the Henry Michalski Postcard Collection.)

Jews have served with pride in the military, honoring the values that have helped to define America since the Revolutionary War. Jewish War Veterans (JWV) was founded in 1896 by Jewish veterans of the Civil War. Larry Lattman, a decorated veteran of the Korean War and active in the JWV, is buried with at least 30 other Jews in the cemetery at Veterans Home of California in Yountville. (Courtesy of the Veterans Home of California, Yountville.)

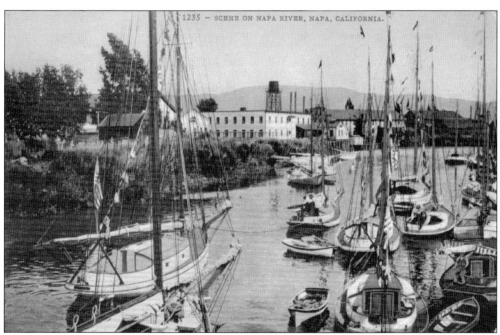

The meandering Napa River was a natural conveyance for goods, including lumber, grain, leather, and wine. Its drainage into San Francisco Bay connected Napa to the greater world. This lifeblood of commerce attracted settlers, farmers, and businessmen to idyllic settings along its banks. Pioneering Jews traded everything the emerging population would need until permanent structures could be built. (Courtesy of the Henry Michalski Postcard Collection.)

43

Albert Eugene Kufflevitch worked in his father's meat market in Warsaw before being called to serve in the Polish military. Escaping to America, he boarded a ship at Port Arthur, Texas, eventually arriving in San Francisco. "Al Kaufman" found work in a butcher shop. Shortly after the 1906 earthquake, he met and married Doris Biber, a vaudeville entertainer, and the long union of two high-spirited adventurers began. (Courtesy of Rozaline Johnson.)

Kaufman worked briefly as a cowboy in Novato. Deeming this kind of work too hard, he and Doris rented a small store in Vallejo and sold used furniture to laborers at nearby Mare Island. In 1909, Rozaline was born; she inherited unbridled energy from her mother and a sense of adventure from her father. The Kaufman family is pictured here. (Courtesy of Rozaline Johnson.)

Rozaline made fancy lace and sequin gauze protection masks during the influenza epidemic of 1918, but her true passion was performing as a singer, dancer, and violinist. Making her own costumes, she toured with a troupe called the Million Dollar Kitties. She went on to study at the College of the Pacific. The crash of 1929 forced her to work at Hale's Department Store in San Francisco. (Courtesy of Rozaline Johnson.)

Rozaline loved horseback riding. She is pictured on the right riding her horse, Lady West Wind, with friends in Pope Valley. Active in the Napa Valley Horsemen's Association, she toured Hawaii with the group, where she met and married Army officer Bert Johnson after a whirlwind courtship. Together, they rode horses and were "rock hounds" and philanthropists. They purchased 43 acres near the Silverado Trail, where they lived for the next 50 years. (Courtesy of Rozaline Johnson.)

Known as "Mr. Pants," Nathan Rothman came to America in 1906, penniless and with no knowledge of English. His garment business career began in 1919 when he took his life savings of $500, rented a loft in San Francisco, and started the Rough Rider company. To make way for the new Bay Bridge, Rothman moved the company to Napa in 1936 and opened a factory that became a showplace of the industry. (Courtesy of the Rothman family.)

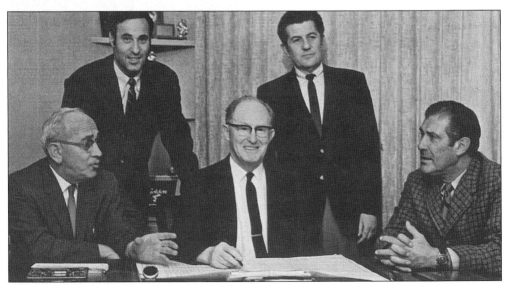

In its heyday, Rough Rider employed 900 persons and became the largest employer in Napa. Its mostly Jewish executives became active in the community and the synagogue. Julian Weidler, center, was president from 1955 to 1970. With him, from left to right, are vice president Dan Weinstein, secretary-treasurer Morton Rothman, assistant salesperson Bert Margolis, and vice president and merchandising manager Don Boverman. (Courtesy of Julian Weidler.)

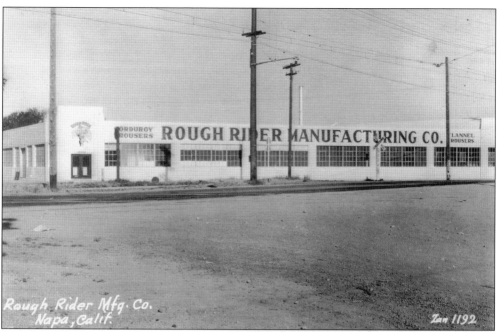

Rough Rider Mfg. Co.
Napa, Calif.

Hungry for industry during the Depression, Napa leaders launched a campaign to "Move Rough Rider to Napa," raising $40,000 to purchase land along the Napa River on Soscol Avenue, which the company could own if it hired 300 people. One employee was 18-year-old George Altamura. Modeling himself after successful Jewish entrepreneurs, Altamura became one of Napa's most successful businessmen. (Courtesy of the Henry Michalski Postcard Collection.)

Rough Rider added woolen slacks to its line in 1932, and it was the first company to put zippers in pants. The company closed in the late 1970s, and the building was torn down in 2002 as part of the Napa Flood Control Project. True to the company's policy of *Tikkun Olam*, meaning "repairing the world," lumber from the interior was used to build migrant farmworker housing. (Courtesy of Julian Weidler.)

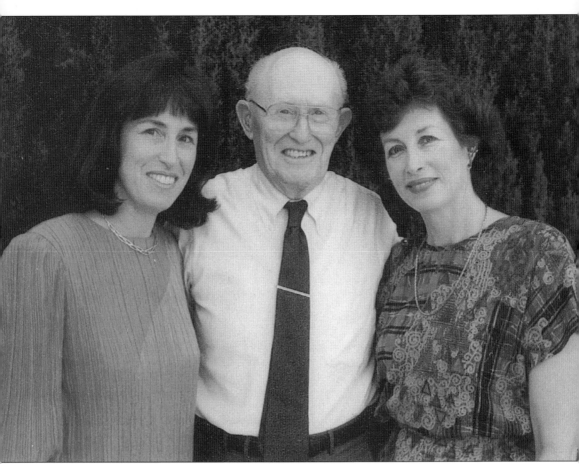

Julian Weidler is shown here (center) with daughters Leah Suffin (left) and Jacqueline Weidler Nissom. Well into his 90s, every morning Weidler drove to his office at the Gasser Foundation, where he devoted his time to doing mitzvot (Hebrew for "charitable acts") for the community he loved and truly living a life of *Tikkun Olam*. In August 2011, as Weidler approached the exalted age of 100, leaders of the community came together at Congregation Beth Sholom, the shul he helped to found, to honor this remarkable man. As Weidler was surrounded by the family he loved and the grateful community he had helped, Mayor Jill Techel presented him with a key to the city. Supervisor Brad Wagenknecht presented a resolution naming Weidler the "King of Volunteers for his service to the city." George Altamura, whose first job in Napa was pressing pants at Rough Rider, said of him, "He was like the brother or friend everybody would like to have." That night, without a stir, Weidler departed from this world. (Courtesy of the Weidler family.)

Three

BAGELS, BLINTZES, AND B'NAI B'RITH
A JEWISH COMMUNITY EMERGES
(1940–1965)

ועשו לי מקדש; ושכנתי בתוכם.

And let them make Me a sanctuary that I may dwell among them.

—Exodus 25:8

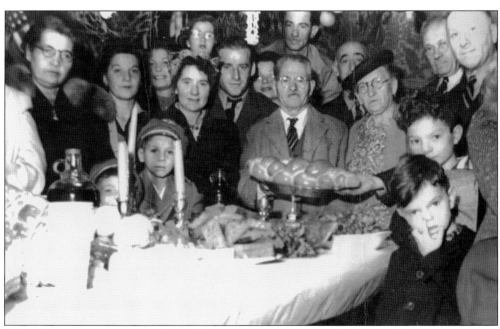

Before there was a permanent shul in Napa, there were Jews who felt the need for companionship, spirituality, and Jewish learning—and a place for their children. For years, the Napa Jewish Group celebrated at Jonafred Farms. Here, Samuel Lazarus proudly displays a challah at the head of the Sukkot table with his wife, Annie, in the black hat. Together, they were affectionately known as Papa and Mama Lazarus. (Courtesy of CBS.)

Fred and Bella Rosenthal escaped from Germany with their 10-year-old daughter, Lottie, shortly after *Kristallnacht*. Arriving in Napa, they partnered with cousins John and Helen Marx to form Jonafred Farms. Located on West Salvador Avenue (now Wine Country Road), the chicken farm hosted many Jewish celebrations. Raising fryers and turkeys was quite a departure from selling textiles, which is what Rosenthal did in Germany. (Courtesy of the St. Helena Public Library.)

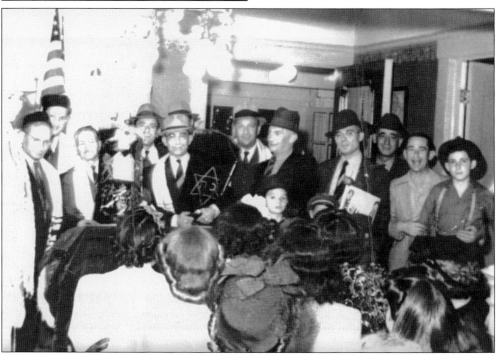

Prior to forming a permanent congregational synagogue, some locals schlepped to Congregation B'nai Israel in Vallejo or to San Francisco for the High Holy Days. The Napa Jewish Group met in various locations, such as Joseph Lazarus's store on Main Street or in the Kaufman home. Often they were observed in Ben and Bea Baylinson's welcoming home (pictured here), the largest one available. (Courtesy of CBS.)

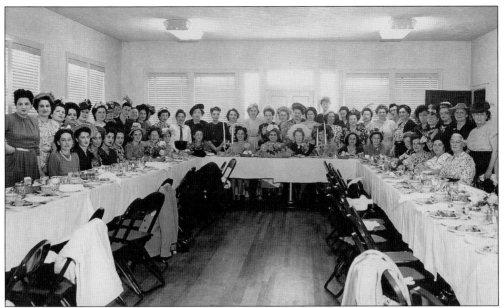

Sisterhoods were dedicated to serving their congregations. In the 1940s, the Vallejo B'nai Israel Sisterhood included women from Napa, since Napa did not then have an established synagogue. The women promoted sociability, provided flowers, raised funds, and transmitted Judaism through programs and study. Fundraisers featuring lox and bagels or blintzes were a sure-fire success. (Courtesy of CBS.)

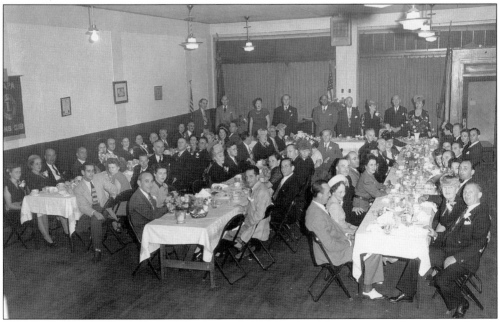

B'nai B'rith (Sons of the Covenant) began in 1843 and is the oldest continuously operating Jewish service organization in the world. The group speaks out for Jewish rights. In 1913, in direct response to the trial and lynching of member Leo Frank, the Anti-Defamation League was founded. The Napa Valley Lodge of B'nai B'rith first convened at Lions Hall in October 1946. Lottie, Bella, and Fred Rosenthal are on far left, from left to right. (Courtesy of Julian Weidler.)

The Napa Valley B'nai B'rith Women was founded soon after the men's organization. Here, group members present a play in 1954. Seated is Joanne Abraham. Standing, from left to right, are Helen Goldman, Bea Baylinson, Deborah Euster, Lucile Charlup, and Jacqueline Lazarus. The B'nai B'rith Youth Organization for Jewish teens was formed in 1961 jointly with B'nai Israel and Beth Sholom. (Courtesy of CBS.)

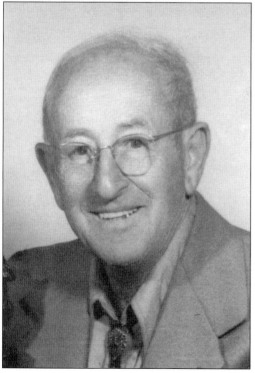

Born in Russia in 1897, Yosel Paltiel moved with his family to England. British immigration gave his father, Shmuel Lazar Paltiel, the last name of Lazarus. After the family left England for Canada, Yosel (calling himself Joe Lazarus) snuck into Detroit and drifted until reaching Napa in the 1920s. At a picnic in Oakland, he met May, a singer; they married two months later. Lazarus is pictured here. (Courtesy of Cindy Kirkland.)

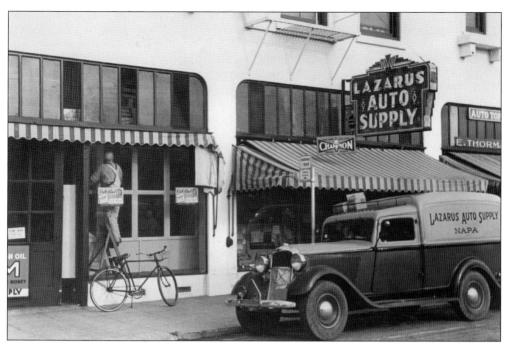

The Lazarus family ran an auto parts business on Napa's Main Street. With an estimated 100 adult Jews living in Napa, the Napa Jewish Group began, with Lazarus serving as president. Most Napans went to Vallejo for services, but Lazarus allowed the group to use the lodge hall on the second floor of his downtown building. (Courtesy of Cindy Kirkland.)

The Lazaruses purchased the Reavis Hotel at 1032 Main Street (next to the opera house) and renamed it the Major Building after May and Joe Lazarus. They were among the founders of Congregation Beth Sholom and the first to contribute toward a fund to purchase a permanent home for the Jewish community. An activist, philanthropist, and friend to all, Joe lived to the age of 97. (Courtesy of Cindy Kirkland.)

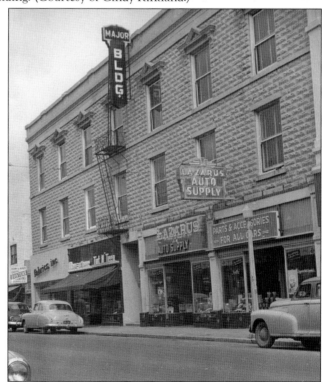

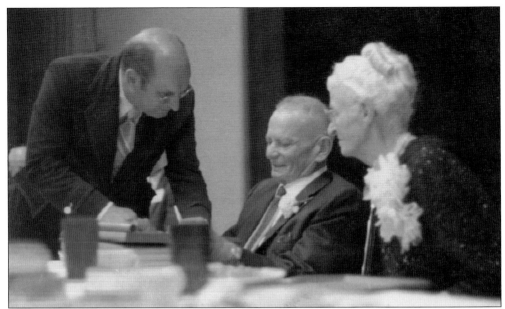

Born in 1893 in Alsace-Lorraine, France, Dr. Arnold Hauser took his first medical post during World War I. His wife, Claire, became his assistant. In 1938, the couple fled Germany with their three children. Completing a California medical board examination, Dr. Hauser became the first Napa pediatrician, even as an "enemy alien," dividing his time between Vallejo and Napa. Earl Randol, left, honors the couple at a retirement party in 1973. (Courtesy of Gail Randol.)

Oscar Tanenbaum met Luba Abramowicz at a displaced persons camp after World War II. He adopted her son, Harvey, whose father had died before he was born. The family lived and worked at Oscar's Junkyard; today, the street on which it was located is called Tanen Street. (Courtesy of Myrna Abramowicz.)

Harvey Abramowicz, shown here working in the junkyard as a young man, was educated in Napa schools. Embarrassed by his meager circumstances, he went on to become president of the Toastmasters and was given the David Ben-Gurion Award for his work supporting Israel. He became a successful realtor in the valley, as well as principal of the Congregation Beth Sholom's religious school. (Courtesy of Myrna Abramowicz.)

Abramowicz met Myrna, who came to San Francisco from New York. Their son, Steven, was born in 1971. Abramowicz "sounded the shofar" until his death from leukemia in 1977 at age 37. His bronze sculpture *Dachau Sabbath* is displayed at Congregation Beth Sholom. Myrna was a college board member, a Napa Valley Expo board member, and a founder of Napa's Hadassah. She taught Sunday school and operated her own business, Sample and Save. (Courtesy of Myrna Abramowicz.)

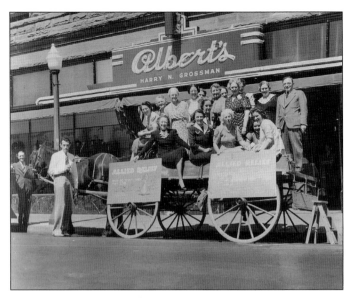

The Allied Relief Fund float is pictured in front of Albert's department store, owned by the dapper Harry N. Grossman and his younger brother, Samuel. Downstairs, the store sold jewelry, fine dresses, and men's suits. Upstairs held a shoe department and housewares. Roslyn, Grossman's daughter, married Mervin Morris, who eventually took over Albert's and renamed it Mervyn's. (Courtesy of the Napa County Historical Society.)

Grossman, a sportsman and "ladies man," is second from left with, from left to right, Arthur Fox, Bill Bryant, and Doug Craik of the Napa Polo Team. Besides co-running Napa's most successful department store, the Grossman brothers never forgot to perform their civic duties, serving in many capacities. Samuel was appointed to the advisory board of Napa State Hospital and Harry served on the grand jury. (Courtesy of the Napa County Historical Society.)

This advertisement from 1945 sent customers to Albert's, where the managers were impeccably dressed. There were no cash registers on the main floor, so change from a purchase was sent via the pneumatic tubes. The office upstairs was constantly interrupted by the banging of tubes, which shot up cylinders that opened with a twist and spilled out cash and a sales slip. Courtesy of the Napa County Historical Society.)

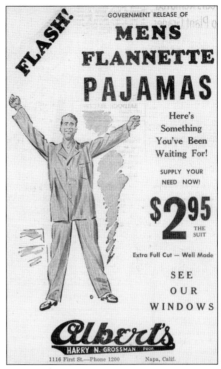

Harry Grossman's Italianate-style home at 447 Randolph Street in Napa, designed by noted architect Luther M. Turton, was loaned for several weeks to Carole Lombard in 1940 when she and Charles Laughton were filming *They Knew What They Wanted* in Napa Valley. The Grossmans were impressed with how genial Carole and her husband, Clark Gable, were. Most of the film's scenes were shot in Oakville. (Courtesy of Henry Michalski.)

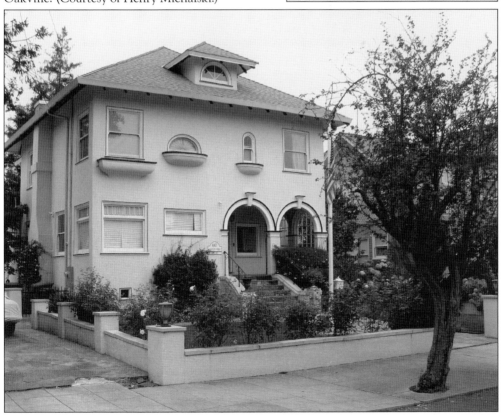

Wes Meyer served in the ROTC while at the University of California, Berkeley, and entered the Army Air Corps shortly after Pearl Harbor. He became a combat photographer, which took him to Rome and a private meeting with the Pope, who secretly knew Meyer was Jewish. Later, in Napa, Meyer was involved in many civic organizations, including serving as president of the Kiwanis Club. (Courtesy of Ellie Meyer.)

Ellie Bickoff and her big brother, Mel, shared an apartment while attending the University of California, Berkeley. Ellie met Wes Meyer at a Jewish mixer at the International House. He invited her to go for ice cream, and they were soon married; he was 21 and she was 18. Pictured in 1950 are the Meyers with their children, Sharon, Gary, and Barbara. (Courtesy of Ellie Meyer.)

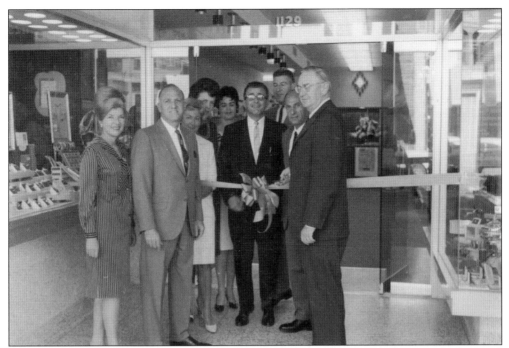

Wes's father, Isadore, rewarded his war-hero son with a partnership in the Vallejo jewelry business. Wes enthusiastically opened branches in Fairfield, Vacaville, Petaluma, and Santa Rosa, and later opened jewelry departments in large discount chains in Stockton, Modesto, and San Rafael. Ellie and Wes (both left) stand proudly outside their new Napa store, which opened on First Street to great fanfare in September 1965. (Courtesy of Ellie Meyer.)

In 1950, Lottie Rosenthal visited relatives in Washington Heights, a Jewish enclave in upper Manhattan, where the Rosenberg brothers, also German refugees, ran a nearby delicatessen. Lottie and George Rosenberg noticed each other, and on Lottie's return to Napa, they began a correspondence courtship that resulted in marriage. From left to right, Linda Marx, Lottie, and Jo Ann Marx are shown on June 17, 1951, before the wedding festivities began. (Courtesy of Lottie Rosenberg.)

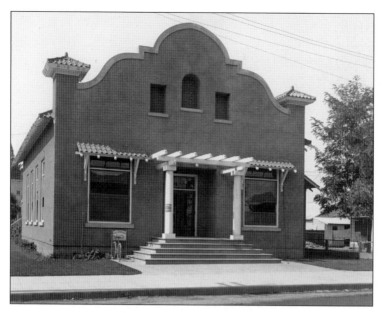

The Napa Chamber of Commerce building had outlived its usefulness. In 1956, the city sold it to the Jewish community for $1, provided they would relocate it. The building was sawed in half and moved to its present site at 1455 Elm Street. Incorporation papers were drawn up for Congregation Beth Sholom. (Courtesy of the Charles B. Turrill Collection, Society of California Pioneers.)

Remodeled in 1960, the *Napa Valley Register* said in 1966 that the Congregation Beth Sholom building "is one of the most attractive religious structures in the community." Its founders included Danny Weinstein, Sam Weinstock, Bella and Fred Rosenthal, Helen and John Marx, Ethel and Bert Margolis, Gussie Mann-Eidelsheim, May and Joe Lazarus, Rose and Chick Gordon, Shirley and George Gordon, Bea and Ben Baylinson, Lottie and George Rosenberg, Sylvia and Julian Weidler, and Ellie and Wes Meyer. (Courtesy of Lynn Michalski.)

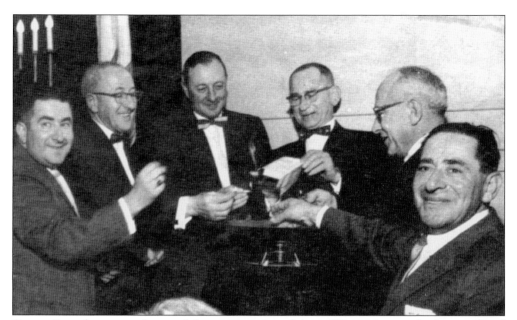

George Rosenberg expertly served the congregation of about 150 members as the first unofficial rabbi and lay leader. In December 1960, at an elaborate ceremony, the mortgage on the remodeled building was symbolically burned by synagogue leaders, from left to right, George Rosenberg, Joe Lazarus, Chick Gordon, Ben Baylinson, Danny Weinstein, and John Marx. (Courtesy of CBS.)

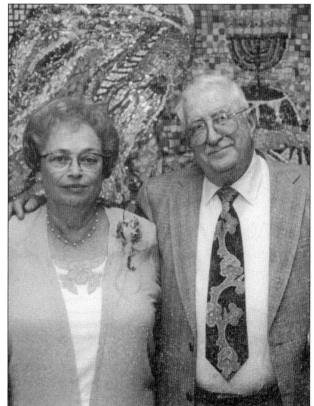

George Rosenberg was a catalyst for the burgeoning Jewish community. When not at the synagogue, he ran Rosenthal Dried Fruits and Nuts. The store's pistachios, sold in a wine bottle, were originally thought to be pistachio wine by the advertisement company hired to promote them. The business was sold to the Milusos and is now Napa Nuts. Shown here are Lottie and George Rosenberg at the 40th anniversary celebration of Congregation Beth Sholom in 1994. George died in 1998. (Courtesy of CBS.)

Leo Trepp, born in Mainz, Germany, earned his rabbinical and doctorate degrees at the University of Wurzburg. He was ordained in 1936 and married Miriam de Haas in 1938. Leo was arrested on *Kristallnacht* and was the last surviving rabbi in Germany. The couple escaped to England and settled in America. In 1961, this author of *A History of the Jewish Experience* began serving as part-time rabbi at Congregation Beth Sholom. He also taught at Napa Valley Community College and served on the Napa County's Planning Commission. (Courtesy of Gunda Trepp.)

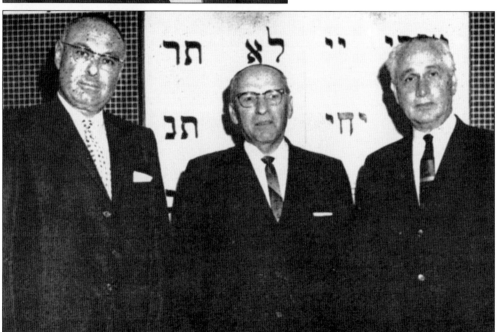

On a Sunday in April 1964, the Napa Jewish Community Center of Congregation Beth Sholom was dedicated. Among those participating were, from left to right, Rabbi Leo Trepp, who gave the benediction, Rabbi Aaron Werner, who gave the invocation, and Rabbi Elliott Burstein, the featured speaker. (Courtesy of CBS.)

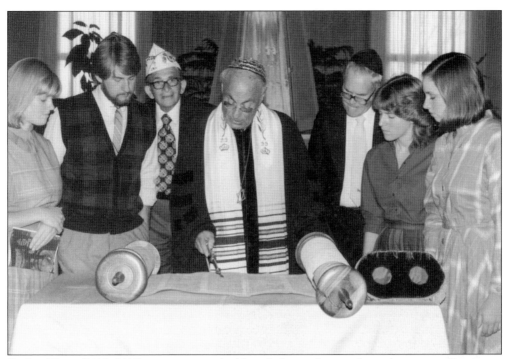

Dr. Leo Trepp (1913–2010) was a respected rabbi, scholar, author, professor, lecturer, and promoter of interfaith understanding. He worked tirelessly to establish a permanent Jewish chapel at the Veterans Home of California, Yountville, and served the spiritual needs of veterans for over 40 years in the chapel dedicated to him. The Leo Trepp Chapel was donated in part by the Bernard Osher Foundation. Dr. Trepp is shown, center, with the Torah. (Courtesy of Gunda Trepp.)

Rabbi Harry Levenberg served patients at Napa State Hospital in its Chapel Etz Hayim. Here he admires the ceremonial Sukkot ("Festival of Tabernacles") table setting prepared by members of Congregation Beth Sholom's Sisterhood. Pictured from left to right after Rabbi Levenberg are Francine Goldstein, Gussie Mann-Eidelsheim, Muriel Gobler, Sylvia Dink, and Luba Tanen, who all belonged to the Sisterhood's hospital welfare committee. (Courtesy of CBS.)

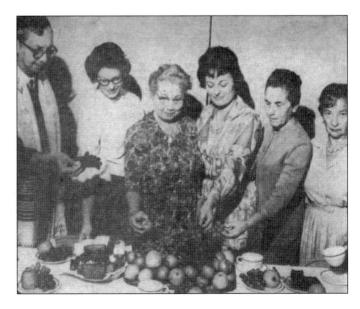

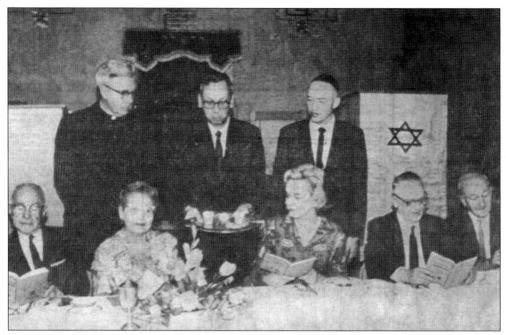

Rabbi Harry Levenberg (standing center) explains the Seder plate for Jewish patients in Chapel Etz Hayim at Napa State Hospital. Looking on (standing left) are Rev. Anthony McNamara, and (standing right) Chaplain Herman Eichorn. Seated, from left to right, are Samuel Muscatine, hospital welfare chairperson Gussie Mann, president of the Congregation Beth Sholom Sisterhood and Napa school board member Donna Heine, superintendent of the hospital Dr. W. A. Oliver, and Joe Lazarus. (Courtesy of CBS.)

In a Napa home, Gussie Mann-Eidelsheim (right), a founder of Congregation Beth Sholom and the president of its Sisterhood, is about to light the Shabbat candles. Looking on is Claire Erks, an active member of Napa's Jewish community and a descendant of Freedman and Dora Levinson, widely believed to be Napa's first Jewish family, arriving at the time of the Gold Rush (see pages 9–10). (Courtesy of CBS.)

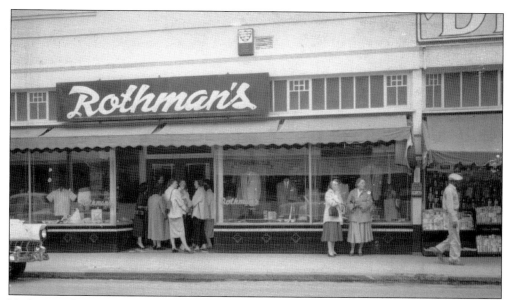

Nathan Rothman's brother, Harry, brought his young family to Napa during the Depression to work at Napa's new Rough Rider plant (see pages 46–47). A generation later, Harry's son Marvin and Marvin's mother bought a struggling clothing store on Main Street, Abe Strauss's men's store, then the second-oldest men's clothing store in California. They renamed the store Rothman's. (Courtesy of Marvin Rothman.)

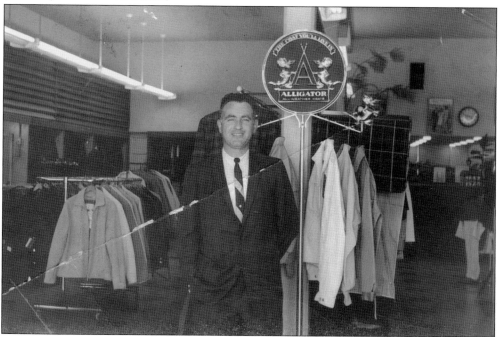

Marvin Rothman (shown here) ran the store by himself for 15 years, until his brother, Leonard, came home from the Korean conflict and bought his mother's half interest. The brothers offered fancy dress slacks and coats made by Rough Rider and did quite well. In the 1980s, Leonard bought his brother's interest in the store. Eventually, Rothman's, like other small clothing stores, gave way to anchor department stores. (Courtesy of Marvin Rothman.)

Morris and Annie Nussbaum left Charleston, South Carolina, in 1947, arriving in Napa in 1954 with their children, Rachel, Minnie, and Harris. That same year, Rachel (right) went with friends to meet Larry Friedman, a San Francisco native returning from Korea. He was wearing a stylish zoot suit. They were married within a year and bought an Army-Navy surplus store (pictured here) in San Francisco with the help of family. (Courtesy of Rachel Friedman.)

Harris Nussbaum (left) worked with his father at the Napa Army-Navy store that Morris bought from Abe Euster. Morris changed the name to Brewster's to rhyme with Euster's. After graduating from college, Harris became a popular business and psychology teacher. His sister, Rachel, and brother-in-law, Larry Freidman (right), took over the store. It became a central meeting place in Napa; prices were always negotiable. (Courtesy of Harris Nussbaum.)

Brewster's slogan was "If we don't have it, forget it, you don't need it anyway!" The Friedmans greeted everyone with a smile (and bargains). Larry's sense of humor carried over into the newspaper. With Bob Hind at the *Napa Valley Register*, he produced years of amusing advertisements, often depicting family members. Rachel later became president of the Downtown Merchants Association. (Courtesy of Rachel Friedman.)

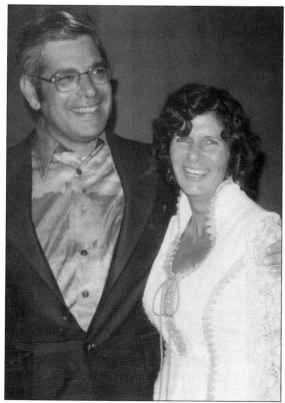

Dr. Abraham Sidney Linn and Terri (Wagner) married in 1952, in Brooklyn, New York. They moved to Napa in 1961 after Dr. Linn served as a captain in the Army Medical Corps. The Linns had three children: Jeffrey, Donald, and Judith. Dr. Linn was appointed medical director of Napa State Hospital. After their divorce, Abraham moved to Massachusetts, and Terri developed expertise in working with survivors of childhood sexual abuse in Napa. (Courtesy of Terri Linn.)

Capt. Eliot Percelay was stationed at Travis Air Force Base in 1963 with his wife, Anne. Sons Stephen and Jack were born on the base, educated in Napa schools, and are practicing physicians. Daughter Debbie was born later. Anne, from Reading, Pennsylvania, has prepared over 50 young children for their bat and bar mitzvot. She has served as synagogue trustee, principal, and Hadassah president. The children, pictured from left to right, are Debbie, Stephen, and Jack. (Courtesy of Anne Percelay.)

New officers for B'nai B'rith (1969–1970) were installed during a meeting at Congregation Beth Sholom. From left to right are Zoltan Rosenberger, owner of the historic Goodman's department store in St. Helena and second vice president; Bernie Marks, installation officer; Gilbert Lambert, first vice president; and Maurice Werner, president. (Courtesy of the *Napa Valley Register*.)

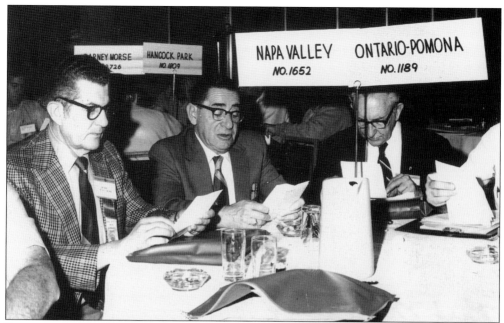

Representing Napa at the 1970 B'nai B'rith Convention in San Francisco are Bert Margolis (left) and John Marx (center) of Napa Lodge 1652. Established in 1946, the members worked on education, social services, and youth activities. By 2001, with declining membership, the lodge disbanded and donated most of its remaining funds to the Congregation Beth Sholom for the library, computers, and the Founders' Glen. (Courtesy of CBS.)

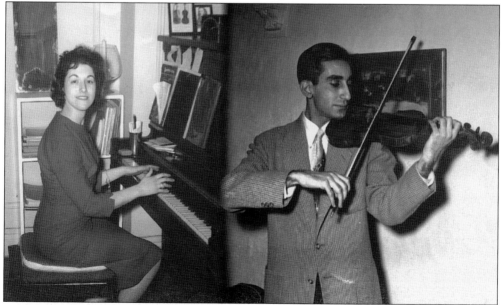

Married for over 50 years, Marcia and Paul Battat, pictured here, raised three child prodigies: pianist and violinist Alanna, pianist and flute player Elizabeth, and pianist and violinist Jeremy. Paul attended Juilliard School of Music and played at Radio City Music Hall. Marcia is the founder of Napa Valley Music Associates, a nonprofit organization dedicated to high-quality music instruction for children and adults; she has taught piano for 40 years. (Courtesy of Marcia Battat.)

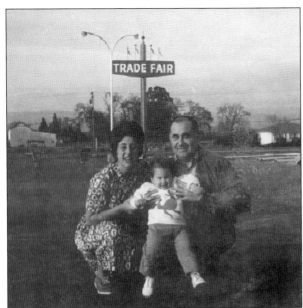

Harry Hamber was born in Frankfurt, Germany, and raised in San Diego. He was a commissioned officer in the US Air force in the 1950s. Jane Hamber was from Illinois and graduated from the University of California, Los Angeles. Debbie Hamber is pictured with her parents at the new Trade Fair department store, which the Hambers opened in 1965. Fred Hamber was born later. (Courtesy of Fred Hamber.)

When Trade Fair opened, it was the largest retail store in Napa County, with 125,000 square feet and 300 employees. The grand opening featured a jump by the Calistoga Skydivers. Upon landing, the skydivers presented the mayor with a pair of scissors for cutting the ribbon. Harry (center) died in 1971 at age 41, and his widow sold Trade Fair a few years later. (Courtesy of Fred Hamber.)

Dr. Alvin Lee Block, a prominent internist and lawyer, is holding son Kevin; his wife, Ina, is holding son Gregory. Lee and his brother, Rodney, shared a medical practice. Lee founded the Jewish Community of Napa Valley, providing support for cultural groups. He has also been involved in the Napa Commission for Arts and Culture, the Napa Valley Opera House, and the Napa County Transportation and Planning Agency. He married Moira (Johnston) in 1989. (Courtesy of Ina Block.)

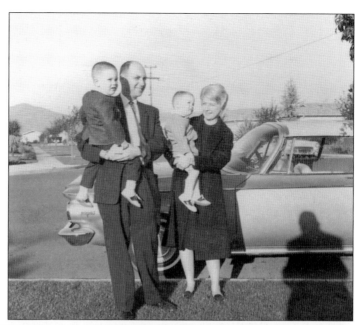

Even though Marvin Winograde grew up in Los Angeles and wife Karen hailed from Chicago, they had a great-grandfather in common. Their three-acre ranch was the site of many happy occasions in their 50-year marriage. From left to right are Joseph, Marvin, Karen, Edie, and Lester. Marvin founded Air Caribbean before partnering with Harvey Abramowicz in Associated Brokers. Karen is a master potter. (Courtesy of Karen Winograde.)

Congregation Beth Sholom Presidents

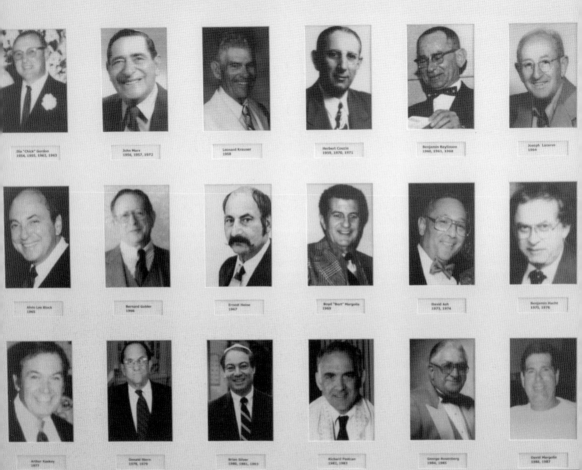

Leading a synagogue can often provide an opportunity to contribute experience, skills, and knowledge to benefit the community. Elie Wiesel states, "To be part of a community, to shape it and to strengthen it, is the most urgent, the most vital obligation facing the Jewish individual." These individuals took up that obligation in the early days of Congregation Beth Sholom's Jewish Community Center. Presidents pictured, from top left to bottom right, are Ilia Gordon (1953, 1954, 1955, 1962, and 1963); John Marx (1956, 1957, and 1972); Leonard Krauser (1958); Herbert Couzin (1959, 1970, and 1971); Ben Baylinson (1960, 1961, and 1968); Joe Lazarus (1964); Alvin Lee Block (1965); Bernard Gobler (1966); Ernest Heine (1967); Boyd Margolis (1969); David Ash (1973 and 1974); Benjamin Hecht (1975 and 1976); Arthur Kaskey (1977); Donald Stern (1978 and 1979); Brian Silver (1980, 1981, and 1993); Richard Pastcan (1982 and 1983); George Rosenberg (1984 and 1985); and David Margolis (1986 and 1987). (Courtesy of Lynn Michalski.)

Four

*L'*CHAIM
AMERICA'S MOST LOVED VALLEY
(1940–PRESENT)

ובנו בתים, וישבו; ונטעו כרמים, ואכלו פרים.

They shall build houses and dwell in them. They shall plant vineyards and enjoy their fruit.

—Isaiah 65:21

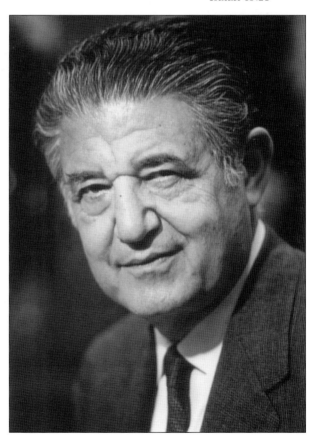

Alfred Fromm, born to a Bavarian family of wine distributors, joined the family firm after graduating from Geisenheim Enological Institute, the leading viticultural school in Germany. In 1936, he married Hanna Gruenbaum and, realizing the Nazi threat, came to New York with $50 in his pocket, where he became a partner in Picker-Linz Importers. In 1937, Franz Sichel, from a family of wine merchants prominent in France and England, teamed up with Fromm. (Courtesy of the Wine Institute of California.)

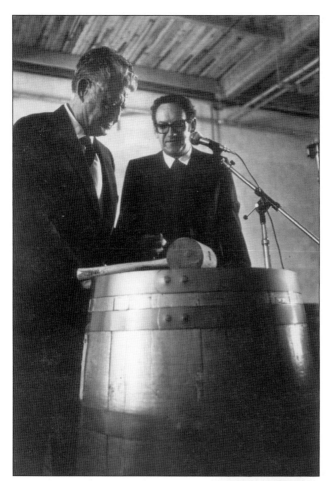

During his time in London, Franz Sichel developed a rewarding friendship with Samuel Brofman of Seagrams. Sichel left Europe for good in 1942, a refugee from the Holocaust. Together, Fromm and Sichel created a wine marketing and distribution system that saved Christian Brothers from bankruptcy. The business expanded to brandy in 1940 and prospered. Their partnership lasted 46 years. Fromm (left) is pictured with Brother Frederick of Christian Brothers. (Courtesy of the Wine Institute of California.)

As newspaperman, lecturer, professor, and public relations executive, Harvey Posert spent over 40 years in wine public relations. From 1965 to 1980, he supervised the Wine Institute of California's award-winning program to educate Americans about California wines. In 1980, he took over Robert Mondavi's public relations department. Harvey authored the widely praised *Spin the Bottle*, containing how-to stories of vintners ranging from Blue Nun to Two-Buck Chuck. (Courtesy of Harvey Posert.)

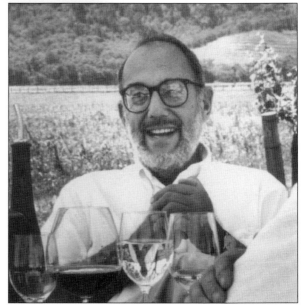

Hanns Kornell (Kornblum) came from a winemaking family in Germany. Escaping Europe after his father died in a concentration camp, he arrived in California in 1940. He leased a little winery in Sonoma and began producing *méthode champenoise* sparkling wine. Pictured here (second from left) c. 1956, pouring at a Valley of the Moon Festival, he had won a State Fair gold for his brut in 1955. (Courtesy of the Wine Institute of California.)

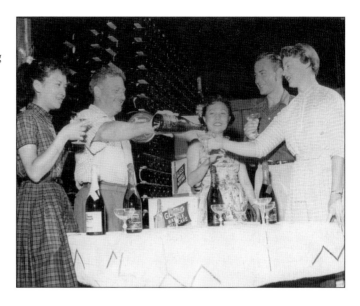

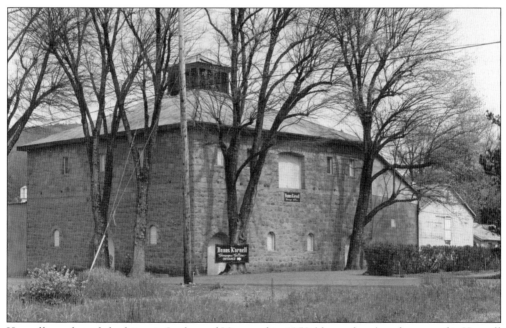

Kornell purchased the historic Larkmead Vineyard in 1958 (shown here) and renamed it Kornell Champagne Cellars. In 1959, his brut champagne won the State Fair gold in the fermented-bottle category. The 1970s brought competition from large, foreign-owned wine cellars. Illness took its toll, and in 1991, the winery filed for bankruptcy. Kornell died in 1994 at age 83. He had made a lasting mark on Napa premium wine. (Courtesy of Napa County Landmarks.)

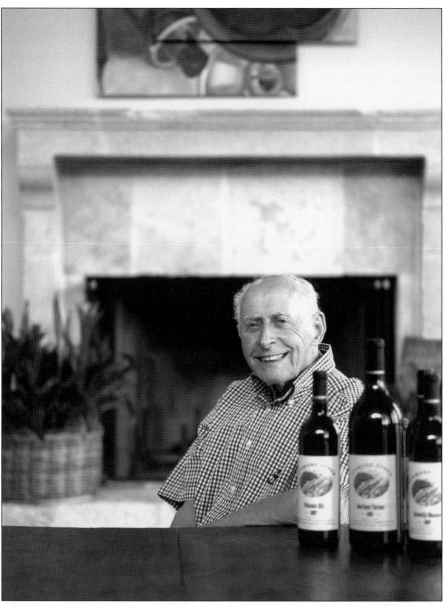

Al Brounstein grew up in Minnesota and, after graduating from college, headed to Los Angeles to find work. He took a wine-tasting course, thinking that selling grapes would be a nice life. He located 20 suitable acres of land on Diamond Mountain near Calistoga for $1,400 an acre, figuring that all he needed were the vines, equipment, and some basic winemaking knowledge to get started. Circumventing Sacramento's red tape in importing budwood, a secret French connection shipped a large bundle of first-growth, premium-quality cuttings to Tijuana. It took seven nightly trips in his small plane to smuggle in the precious cargo, and in 1968, he established Diamond Creek Vineyards. Three distinct soils characterize his estate: red soil full of iron, gray soil rich in volcanic ash, and a gravelly section. In 1978, his cabernets were the first California wines selling for $100 a bottle. Brounstein was the first recipient of the Jewish Vintners Meritorious Service Award. He was an icon of service to the wine industry and the Jewish community. (Courtesy of Diamond Creek Winery.)

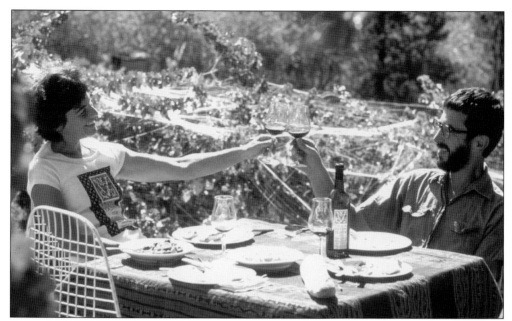

In 1968, Michael and Arlene Bernstein replaced a prune orchard with a vineyard that scaled the slopes of Mount Veeder; some vines were planted at 1,400 feet above sea level. Wine critic Jim Laube hailed their 1973 vintage as one of the top cabernets produced that year. Despite that acclaim, they were denied membership in Napa Valley Vintners due to anti-Semitism. They sold the winery in 1983. (Courtesy of Peter Aaron.)

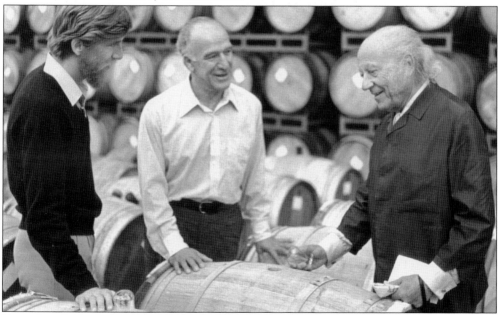

Even though France's Chateau Mouton Rothschild had been damaged by the Nazis and the baron's wife murdered, the winery continued producing superior wines. Robert Mondavi and Baron Philippe de Rothschild hoped they could do the same in Napa Valley with their Opus One Winery. Shown at a barrel tasting, from left to right, are Tim and Robert Mondavi with Baron de Rothschild. (Courtesy of the Wine Institute of California.)

The Finkelstein brothers, originally from Rock Island, Illinois, came to California in the 1960s. Alan Steen (right), a plastic surgeon, moved to St. Helena with his wife, Charlene, an attorney, and their family. Art Finkelstein, an architect, moved there with his wife, Bunnie, and their son, Judd, soon afterward. Art designed Whitehall Lane Winery and the brothers began making wine in 1979. (Courtesy of Bunnie Finkelstein.)

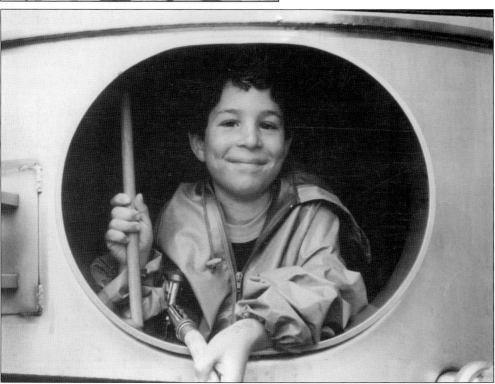

Judd Finkelstein, shown here at age eight cleaning out a wine tank, follows in the family business started in Russia by a cordial-making great-grandfather. Whitehall Lane Winery, family owned from 1979 to 1988, gave way to the boutique and microcrush custom winery called Judd's Hill, located on Silverado Trail. A musician, artist, culinary genius, and beloved charitable sponsor of many events in Napa Valley, Art Finkelstein died in 2010. (Courtesy of Bunnie Finkelstein.)

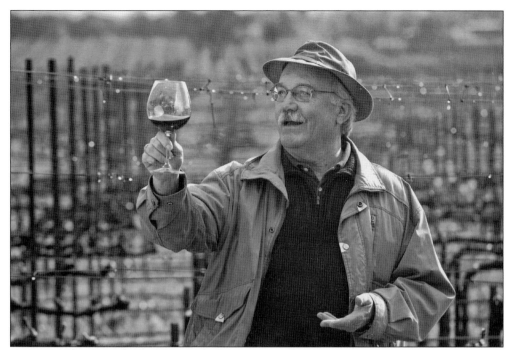

Tucker Catlin met Anita Goldberg in high school outside Chicago. He moved to Israel, converted to Judaism, obtained Israeli citizenship, and the two married. Moving to Napa in 1972, Catlin received his degree in viticulture at the University of California, Davis. After working at prestigious wineries, he now specializes in vineyard design and development. (Courtesy of Tucker Catlin.)

Al Brounstein battled Parkinson's disease for 23 years. He was bar mitzvahed at age 85 at Shavuot in the Vineyards, which he and his wife, Boots, hosted annually. Pictured in 1980 are, from left to right, Bunnie and Art Finkelstein, Boots and Al Brounstein, George Rosenberg, and Rabbi David Kopstein. Boots established Diamonds in the Rough to help find a cure for Parkinson's. Brounstein, who died in 2006, was inducted into the Vintners Hall of Fame in 2009. (Courtesy of Henry Michalski.)

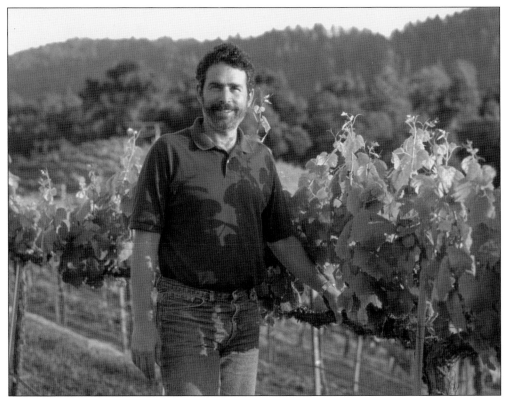

Zack Berkowitz started out at Domaine Chandon as a nursery worker and eventually became vice president of vineyard operations. He worked there for 26 years before starting his own consulting business. He served as president of the North Coast Viticulture Research Group and the Carneros Quality Alliance and is an original member of the Napa Sustainable Winegrowing Group. (Courtesy of Domaine Chandon.)

Ernie Weir arrived in Napa in 1974. He worked at Domaine Chandon while studying for his degree at the University of California, Davis. Building his own winery, Hagafen (Hebrew for "the vine") Cellars, he produces "fine wines that just happen to be kosher," which have been served at the White House. He and his wife, Irit, an acupuncturist and artist from Israel, engage in "living-room dialogues" between Arabs and Jews during frequent trips to Israel. (Courtesy of Kopol Bonick Studio.)

Jan Shrem, born in Columbia to Lebanese Jewish parents, grew up in Jerusalem and started a reference publishing company in Japan in 1955. Meeting Mitsuko there and eloping to Europe in 1968, they built a publishing empire and collected art. Jan took enology courses at the University of Bordeaux in 1980. Following a competition sponsored by the San Francisco Museum of Modern Art, renowned architect Michael Graves designed the 450-acre Clos Pegase Winery, "a temple to wine and art," in Calistoga in 1984. (Photograph by J.L. Sousa, courtesy of the *Napa Valley Register*, ZUMA.)

The winery and caves contain nearly 1,000 works of original art. The couple established the Jan and Mitsuko Shrem Art and Wine Educational Foundation to promote the culture and history of the arts and wine. Married for 50 years, Mitsuko died in 2010. (Courtesy of JHSNV.)

In the northeast Napa Valley hills, French Jewish businessman Robert Skalli purchased the Dollarhide Ranch in 1982 and planted 425 acres of vines. The Skalli family has made wine for three generations in southern France, including a kosher wine. In 1986, Skalli acquired a 56-acre vineyard in Rutherford with an 1882 Victorian home, where he built St. Supéry. (Courtesy of St. Supéry Vineyard and Winery.)

Daniel Baron moved to California from Brooklyn in 1968 and worked in Sonoma vineyards. Completing his master's studies in viticulture and enology at the University of California, Davis, in 1978, he served as assistant winemaker in Alexander Valley, and then traveled to France and worked in Bordeaux. Returning to California in 1982, he helped to launch a new winery. In 1994, he succeeded Silver Oak's Justin Meyer as winemaker, where he produces outstanding cabernets. (Courtesy of JHSNV.)

Michael and Stephanie Honig operate Honig Winery on a 64-acre ranch in the heart of Napa Valley, purchased by Michael's grandfather Louis in 1964. Michael's father, Bill, is the former California superintendent of public instruction. In 1984, at age 22, Michael took over management of the vineyard and winery. The Honigs and their three young children travel the globe promoting, selling, and marketing Honig wines. (Courtesy of Stephanie Honig.)

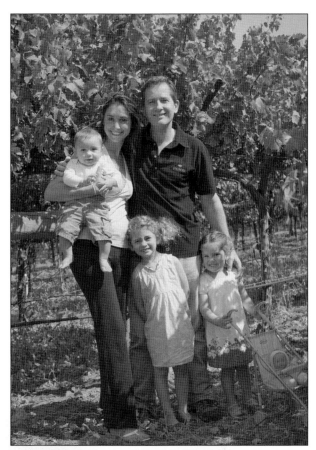

In 1985, little did Dr. Alvin Lee Block realize that he would be starting a controversy when he and a group of investors purchased the old Southern Pacific right-of-way, hoping to run tourist trains through Napa Valley and make stops at various wineries. That history is chronicled in his book *A Dragon Is in the Valley: The Founding of the Napa Valley Wine Train*. (Courtesy of the Napa Valley Wine Train.)

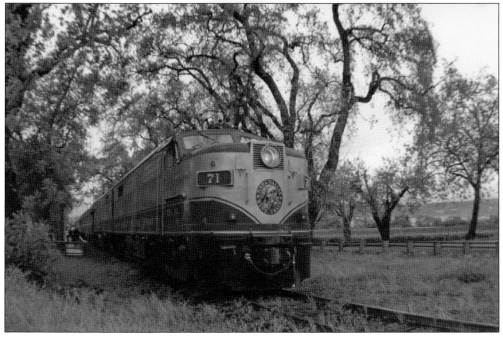

Leslie Rudd, entrepreneur, philanthropist, and connoisseur of food and wine, first joined his parents in the family business, Standard Beverage Corporation. Owner of Rudd Winery, Edge Hill Estate, PRESS Restaurant, the Dean & Deluca retail chain, and Distillery No. 209 in San Francisco, he also established the Rudd Center for Food Policy and Obesity at Yale University and the Rudd Center for Professional Wine Studies at the Culinary Institute of America at Greystone in St. Helena. (Courtesy of Rudd Winery.)

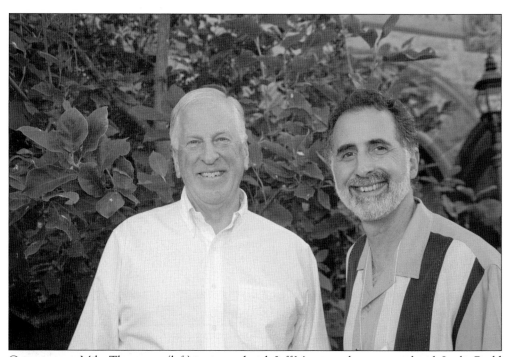

Congressman Mike Thompson (left) is pictured with Jeff Morgan, who partnered with Leslie Rudd to make an unparalleled kosher wine. They sourced grapes from Napa Valley's finest vineyards, starting with a cabernet sauvignon that garnered high ratings. Robert Parker described Covenant as "the finest kosher wine on Planet Earth." The winery also produces chardonnay and sauvignon blanc. (Courtesy of Kopol Bonick Studio.)

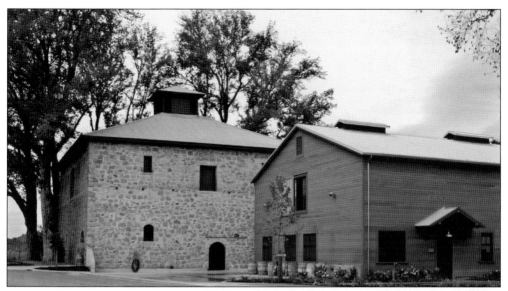

Rich Frank, former president of Disney Studios, and his wife, Connie, founded Frank Family Vineyards (shown here) in 1992 at the historic Larkmead (Kornell) Winery (see page 75). They gained critical acclaim for their still and sparkling wines. Richard received an honorary doctorate from the American Film Institute. Connie sponsored the Connie Frank Transplant Center at the University of California, San Francisco. (Courtesy of Frank Family Vineyards.)

Pictured with his daughter, Sara, former internist Dr. Jan Krupp sold his practice in 1998. With over 100 men tending the vines in the Krupp Brothers vineyards, he often treats their ailments while producing extraordinary wines on his Atlas Peak acreage. Along with his brother, Bart, Dr. Krupp has expanded his acreage and the quality of his fine wines. (Courtesy of Kopol Bonick Studio.)

A 2007 Award of Merit was presented by Napa County Landmarks to Marvin Shanken Communications and the *Wine Spectator* for the rehabilitation and adaptive reuse of the Noyes mansion at 1750 First Street in Napa. The home, built in 1902, was remodeled into offices. Shanken has built *Wine Spectator* into the wine magazine with the largest circulation in the world—it reaches over two million readers. (Courtesy of Henry Michalski.)

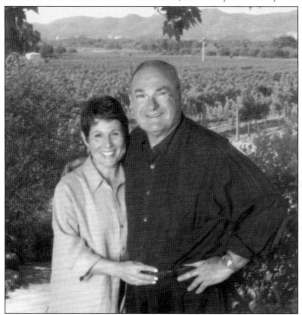

Following a 30-year career in jewelry manufacturing, Suzie and Paul Frank relocated to Napa Valley to fulfill a dream. As a longtime student of geology and viticulture, Paul successfully searched for a vineyard site that replicated many of the great sites of Bordeaux. The resulting Gemstone Vineyard in Yountville has become one of the most highly rated cabernet blends of Napa, regularly selling out its new releases. (Courtesy of Suzie and Paul Frank.)

Richard Mendelson, wine lawyer and counsel to the Napa Valley Vintners, crafted two laws to promote Napa and successfully defended one of them in the California Supreme Court. The author of two books on wine law and history, he teaches at the University of California, Berkeley, and is president of the International Wine Law Association. He is also a vintner and gifted metal sculptor. (Courtesy of Richard Mendelson.)

In 1977, Eric Sklar's parents purchased property in Rutherford. Eric helped by driving a tractor to till, drag, and spray the vines. That property is adjacent to Alpha Omega Winery, where he is cofounder and managing partner. Serving on the St. Helena City Council from 2003 to 2010, he was elected to the board of Napa Valley Vintners in 2010. Picking grapes are, from left to right, Elizabeth, wife Erica, Eric, and Charlotte "Charley." (Courtesy of Eric Sklar.)

WineSpirit, cofounded in 2000 by Rabbi David White (left) and David Freed, merges two perspectives: business and spirituality. Freed is a key player in the world of vineyard and winery finance, leading UCC Vineyards Group and chairing Silverado Premium Partners. Rabbi White is an educator, supporter of Israel, congregational leader, and author of *Sippin' on Top of the World*. WineSpirit promotes life balance between the wine world and spirituality. (Courtesy of Kopol Bonick Studio.)

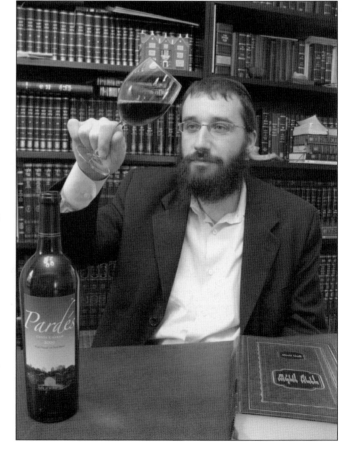

Pictured with his own vintage of Cuvée Chabad, Rabbi Elchonon Tenenbaum and his wife, Chana, have served the spiritual needs of Napans since 2006. Inspired by the teachings of the Lubavitcher Rebbe, they have dedicated themselves to the core principle of *Ahavat Yisrael* ("love of the people of Israel"). Under the tutelage of Jeff Morgan of Covenant Wines, Rabbi Tenenbaum produces fine kosher wines. (Courtesy of Henry Michalski.)

The Blessing of the Grapes has been a Catholic tradition for years. Recently, Jewish vintners have hosted the ceremony, reinterpreting the rich agricultural heritage of Jews, the role played by the fruit of the vine, and the cultural and spiritual links between the Jewish people and the land. Here, in 2008, Rabbi Oren Postrel conducted the service at Judd's Hill Winery. Hagafen Cellars and Gemstone Winery were also represented. (Courtesy of Zoe Kahn.)

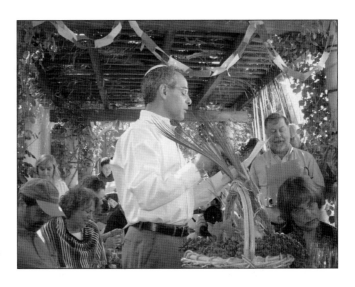

Holly and Judd Finkelstein (left) with the founders of Judd's Hill Winery, Art and Bunnie Finkelstein (Judd's parents), celebrate at the winery, owned and operated by two generations of the family. Producing ultrapremium, handcrafted wines, they approach winemaking as art. Judd's Hill is officially recognized as a Certified Green Business. Holly is a cofounder of the marketing group NG, The Next Generation in Wine. (Courtesy of Kopol Bonick Studio.)

The Matthiassons capture the spirit of old Napa to create cutting-edge wine and maintain sustainability by raising sheep, chickens, and fruit on their historic vineyard property. Steven, a respected viticulture consultant with degrees in philosophy and horticulture, and Jill Klein Matthiasson, who has a master's degree in international agricultural development, nurture sons Harry (left) and Kai in this unique environment. (Courtesy of the Matthiasson family.)

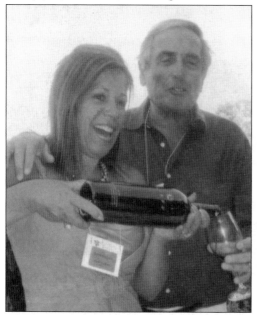

Gretchen and Robert Lieff pour wine from their Lieff Wines. Lieff came to the valley in 1960 as a Columbia University law and business student; after joining migrant farm workers in picking cherries, he vowed to return. In 1966, he was an attorney for the sale of the 12 acres that became Robert Mondavi Winery. Becoming a founding partner of several vineyards, he purchased land across from Auberge du Soleil and recently built his winery. (Courtesy of the Lieff family.)

London-born Stephen Brauer, right, is pictured with, from left to right, wife Maryle, children Isabelle, Emily, and Alexander, and dog Monty. The managing director of Beringer Wine Estates, Brauer has over 24 years of experience in global wine and spirits. His background includes 14 years at Seagram Chateau & Estate Wines, where he helped in the growth of Sterling Vineyards and Mumm Napa Valley. (Courtesy of Maryle Brauer.)

Evan Goldstein apprenticed in prestigious kitchens in Paris and then at Auberge du Soleil. In 1984, he joined his mother, celebrated chef and author Joyce Goldstein, at Square One Restaurant as sommelier. In 1987, he became the eighth and youngest to pass the master sommelier examination at the Court of Master Sommeliers. Since 1990, he has created education programs, wine training, and hospitality schools for major wine houses, also authoring several books. (Courtesy of Kopol Bonick Studio.)

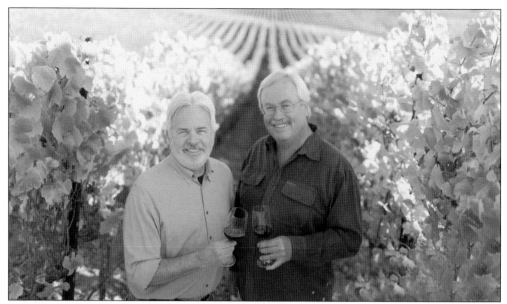

Gary Lipp (left) and Brooks Painter are the partners behind COHO Wines, founded in 2002. Painter, a winemaker for 30 years, is currently director of winemaking at V. Sattui Winery and Castello di Amorosa. Lipp, an alumnus of Robert Mondavi marketing, has held sales and marketing positions at several other fine wineries. He is a past synagogue vice president. (Courtesy of Kopol Bonick Studio.)

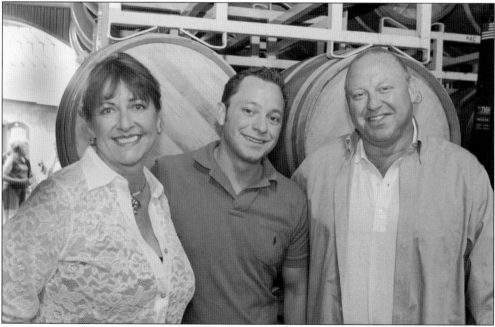

The Preiser Key to Napa Valley is the first and only comprehensive winery and restaurant guide published in Napa Valley. The family enterprise has received accolades from media and wine writers. From left to right is the Preiser family: Sara, son Justin, and Monty. They have held leadership roles in their synagogue and the American Israel Public Affairs Committee. Founders of the American Fine Wine Competition, their wine seminars are legendary. (Courtesy of Kopol Bonick Studio.)

Jim and Carol White are food writers and editors. Jim is also co-owner of Charter Oak Winery in St. Helena, with his partner, Rob Fanucci, producing one of America's great zinfandels. As a product developer, White has brought thousands of premium food products to market. He also founded napaman.com. (Courtesy of Jim White.)

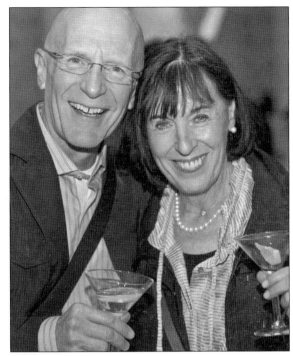

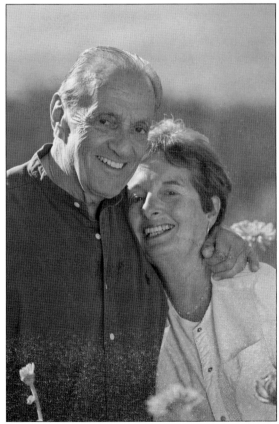

Philanthropists Ronald and Anita Wornick's Seven Stones Winery is home to exceptional cabernet and museum-quality art. Ronald, a food scientist, founded the Wornick Company, which the US Department of Defense selected to produce Meals Ready to Eat (MREs). The Wornicks are benefactors of the Ronald C. Wornick Jewish Day School, Foster City; the Contemporary Jewish Museum, San Francisco; and the Museum of Fine Arts, Boston. (Courtesy of Rocco Ceslin.)

Dick Wollack has a master's degree in business administration from Stanford University and has been in the real estate investment business since 1971. Sue Wollack has master's degrees in special education and psychological counseling and has worked primarily with lower socioeconomic families. The Wollacks have long been involved in the nonprofit world and Democratic politics. Sue served as a trustee for the di Rosa Preserve, and they were recipients of the Anti-Defamation League's Community Leadership Award in 2010. (Courtesy of Sue Wollack.)

Allen Balik founded Club Essence—Savor Life through Wine to further his role as collector, consultant, educator, and author. He writes a wine column for the *Napa Valley Register*. Barbara Balik, a professional photographer, has been with the Cystic Fibrosis Foundation for many years as director of special giving. Together they founded "A Culinary Evening with the California Winemasters," raising $23 million for the foundation. (Courtesy of Kopol Bonick Studio.)

The celebration of Napa's Jewish winemakers began in the 1980s when Congregation Beth Sholom hosted wine tastings benefiting State of Israel Bonds. In 2001, the synagogue hosted events at the Rudd Oakville Estate, Diamond Creek Winery, and Clos Pegase Winery. In 2006, L'Chaim To Life was created, an extraordinary weekend that included a Shabbat reception and dinner, a picnic lunch and grand tastings, a gala dinner and auction at Silver Oak Cellars, a Sunday brunch, and winery open houses. (Courtesy of Barbara Balik.)

Enjoying a "bit of the grape" at a Jewish Vintners event at the Culinary Institute of America at Greystone are golfing buddies and wine connoisseurs, from left to right, Jay Blitstein, Don Kreiger, Bob Ross, Paul Bloomberg, and Ron Schneider. They definitely agree that wine is "good for the Jews." (Courtesy of Kopol Bonick Studio.)

The Jewish Vintners events of 2007 and 2008 were held at the Culinary Institute of America at Greystone, returning full circle to the late-1800s crown jewel of the California Wine Association (see page 38). The events showcased over 40 Napa Jewish vintners as well as Israeli winemakers during a fantastic weekend sponsored by L'Chaim Napa Valley, which was cofounded by Sue and Dick Wollack and Barbara and Allen Balik. (Courtesy of David R. Bennion.)

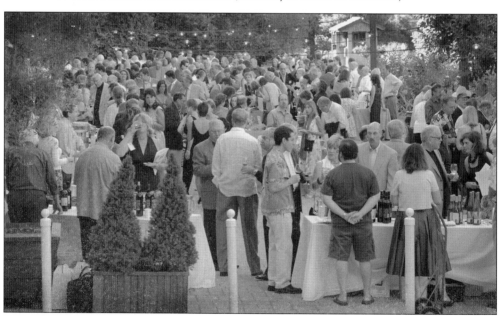

Proceeds from the event went to organizations in the Napa Valley that help children, reduce hunger, and advance knowledge of Jewish history and culture. Art Finkelstein received the Al Brounstein Meritorious Service Award in 2007, and Ernie Weir received it in 2008. (Courtesy of David R. Bennion.)

Five

MODERN JEWISH LIFE
THE PROUD TRADITION CONTINUES
(1965–PRESENT)

הנה מה-טוב ומה נעים שבת אחים גם יחד.

How good and how pleasant it is to dwell together as brothers and sisters.

—Psalm 133:1

Claude Rouas's family had participated in the Jewish life of Oran, Algeria, for five generations. After the end of World War II, Claude left Oran and enrolled in a hotel and restaurant school in Algiers. He graduated at the top of his class and began working at the finest hotel there. Relocating to Paris to work at Maxim's, he is shown here taking a break during the filming of *Gigi*. (Courtesy of Claude Rouas.)

After moving to San Francisco to work at Ernie's restaurant, Claude Rouas opened the acclaimed L'Etoile Restaurant. By 1975, he decided to open a bed and breakfast in the hills of St. Helena. After purchasing land with an olive grove and spectacular views, Auberge du Soleil was born, the first place in Napa Valley to earn a Michelin star. (Courtesy of Claude Rouas.)

The first adult b'not mitzvah at Congregation Beth Sholom was held in 1984. Susan Berlin Jacobs (left), an attorney, died a year later; Martha Pastcan (center) showed her son Benjamin that mothers can read from the Torah; and German-born Hannah Cassel (right), who spent three years in a concentration camp, savored her freedom. Cassel, who came to America in 1948, taught languages at Napa High School. (Courtesy of CBS.)

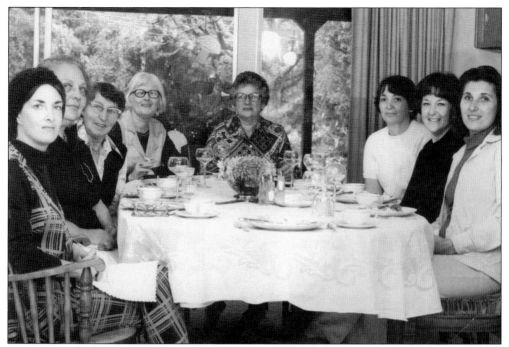

Shown at a 1976 Hadassah organizing meeting are, from left to right, Elizabeth Mautner, Una Kramer, Blanche Miller, Esther Burman, Harriet Wasserman, Myrna Abramowicz, Leslie McCracken, and Anne Percelay. The Napa chapter supported partnership with Israel, progressive health care, youth institutions, and land reclamation in Israel. Zionist youth programs, education, and health awareness are advocated nationally. (Courtesy of CBS.)

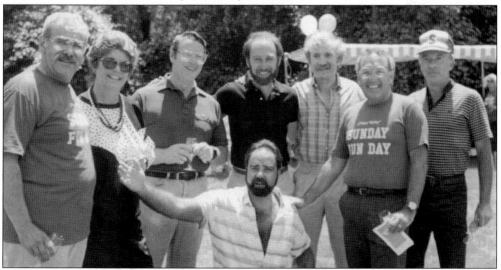

Sunday Funday, a Jewish folk festival held annually at the Reno family's estate in Brown's Valley, was the brainchild of Rachel Friedman. There was Israeli food and wine, children's activities, swimming, dancing, klezmer music, and more to raise funds for the Sunday school. Enjoying the camaraderie of the day are, from left to right, (standing) Larry Friedman, Susan and Bill Lipschultz, Harris Nussbaum, Victor Fershko, Allen Ewig, and Al Rappaport. Henry Michalski is in front of the group. (Courtesy of Henry Michalski.)

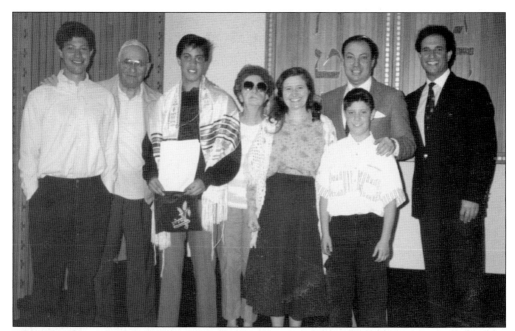

The Silver family is pictured at Adam Silver's bar mitzvah. From left to right are brother Eli, grandfather Benjamin Solomon, Adam, grandmother Ethel Solomon, mother Diane, father Brian, brother Noah, and Rabbi David Kopstein. Ethel Solomon ran the Judaica shop in the synagogue for years. Brian Silver is a Harvard-educated attorney and was a candidate for superior court judge in 1984. Dr. Diane Silver is a dermatologist. (Courtesy of the Silver family.)

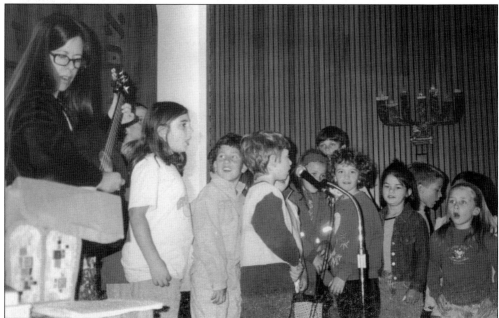

With her guitar, beaming smile, and exuberant love of life, Lisa Iskin (far left) has led a life of sharing, healing, and wisdom, including conducting life-cycle events at Congregation Beth Sholom. Claiming she learned music "by the seat of my pants," for 13 years she was musical director at Napa's synagogue. (Courtesy of Lisa Iskin.)

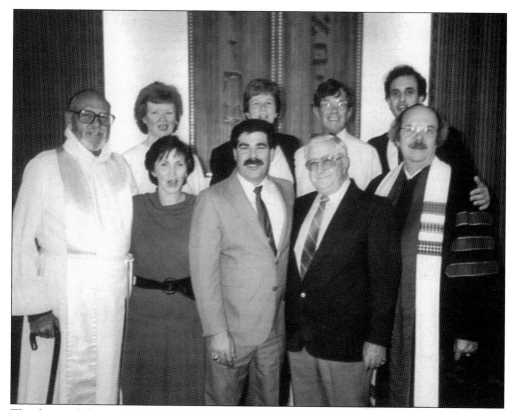

The threat of a hate rally in 1989 united Napa's Christian and Jewish clergy to create an Interfaith Council that worked on issues ranging from fair housing and fighting prejudice to making Napa safer and more tolerant. Pictured at a Shabbat service are members of the council with Congregation Beth Sholom's, president, Alan Koshar (front row, center), and George Rosenberg (to his right). Rabbi Kopstein is in the second row at far right. (Courtesy of Lottie Rosenberg.)

Martha and Richard Pastcan are mainstays of the Napa community. Richard served as chief of pediatrics at Kaiser Hospital and now works at Napa's Clinic Ole. He was president of Congregation Beth Sholom, a High Holy Days Torah reader, and a mohel. Martha was a Sunday school teacher, Sisterhood president, and more. Pictured at daughter Johanna's bat mitzvah are, from left to right, Johanna, son Benjamin, Richard, and Martha Pastcan. (Courtesy of Martha Pastcan.)

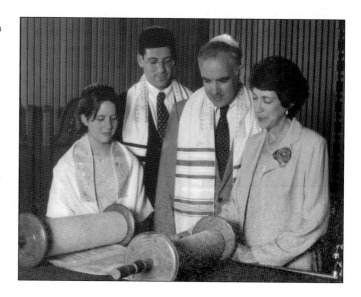

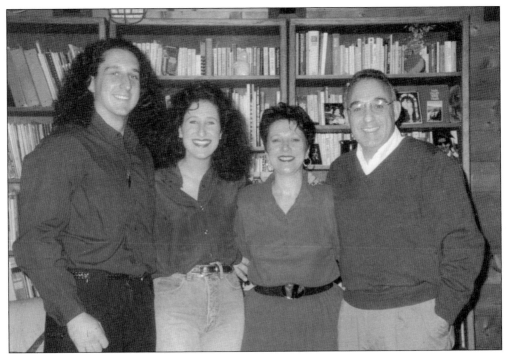

Allen Ewig served as executive director of Aldea Children & Family Services, which offers counseling and mental health programs (among others) and serves 2,500 people annually. Ewig died at age 63, and, in 2008, Aldea moved into the new Allen Ewig building in Napa. Pictured here are, from left to right, the Ewig children, Eric and Rebecca; Allen's wife, Marsha; and Allen. (Courtesy of Eric Ewig.)

Sandi Rubin Perlman was born in England. She and her mother—who was pregnant with her brother, Irv—sailed to Canada during World War II. In 1961, Sandi moved to Napa, and in 1979, she and her husband, Mike Perlman, opened T's and Tops (later called Napa Valley Emporium). At various times, Sandi was president of the Downtown Merchants Association, City Planning Commission, and Napa Chamber of Commerce, and she chaired the Napa River Wine and Crafts Fair. (Courtesy of Sandi Perlman.)

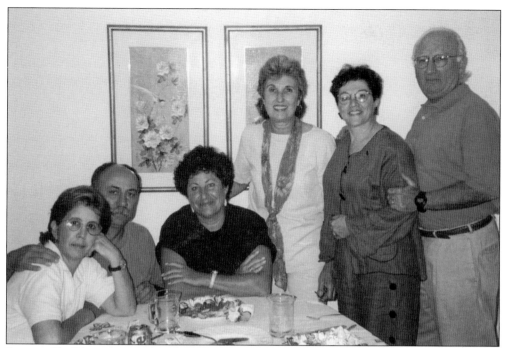

Suzanne Shiff (seated, center) worked at Napa State Hospital for 24 years as a recreational therapist. She has served as president of Congregation Beth Sholom and is active in numerous organizations. She is also the executive director of the Napa Valley Coalition of Nonprofit Agencies. Pictured at Shiff's birthday celebration are, from left to right, (seated) Claudia and Dewey Jalaty, and (standing) Anne Percelay, and Ada and Stan Press. (Courtesy of Anne Percelay.)

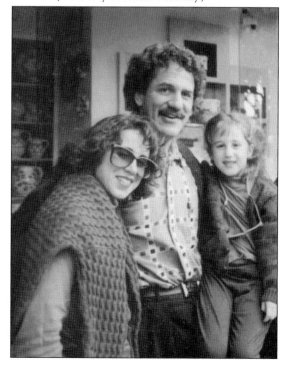

Originally from Montgomery, Alabama, T. Beller (left) came to Napa Valley in 1983. She founded River School, Napa County's first charter school. She serves as commissioner on the Napa County Commission for Arts and Culture and launched the Napa Valley Arts and Lectures Series and the Napa Valley Film Society. From left to right in this c. 1986 photograph are T. Beller; her husband, Dr. Rick Beller; and daughter Erin. (Courtesy of T. Beller.)

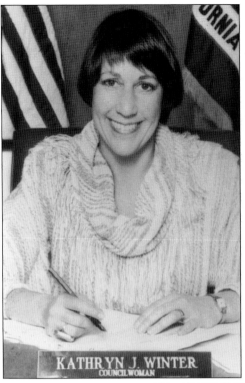

After graduating from the University of California, Berkeley, and Stanford University, Kathryn Winter taught on Arizona's Navajo and Hopi reservations. Elected to the Yountville Town Council in 1982, she then served on the Napa County Planning Commission. In 1996, she was the third woman elected to Napa County's Board of Supervisors. She worked as a senior policy analyst in Gov. Grey Davis's Office of Planning and Research and later directed Fair Housing Napa Valley. (Courtesy of Kathryn Winter.)

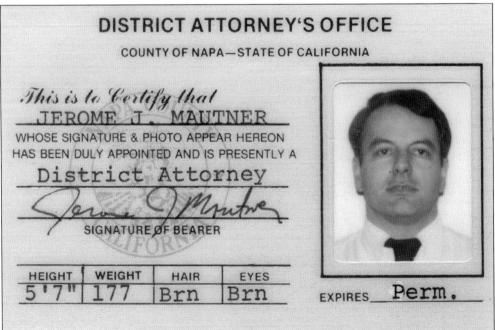

Jerry Mautner, son of a Holocaust survivor, met his future wife, Elizabeth Ellis, at Emory University, Georgia. The family moved to California, and in 1982, he was elected Napa County district attorney. The tough-on-crime district attorney and his elders-advocate wife had five sons; one of them, Michael, is now a deputy district attorney. (Courtesy of Jerry Mautner.)

Barbara Nemko was raised in New York. She received her doctorate from the University of California, Berkeley, and worked for the California Department of Education. In 1997, Barbara was elected Napa County superintendent of schools and in 2004 was named Regional Superintendent of the Year. In 2009, she was named Woman of the Year in California's First Congressional District. She is married to Marty Nemko. (Courtesy of Barbara Nemko.)

Gary Lieberstein grew up in Los Angeles and earned his juris doctor at Hastings College of Law, San Francisco, in 1979. Now serving his fourth term as district attorney of Napa County, he is president of the California District Attorneys Association and chairs many commissions on elder abuse, youth, and gang violence. (Photograph by J.L. Sousa, courtesy of the *Napa Valley Register*, ZUMA.)

Fani Pierce prepares Emma Sabo for her bat mitzvah. For over 30 years, Pierce has tutored nearly 1,000 students for their special day with prayers, Hebrew, and trope. She was born in Morocco, grew up in Israel, and arrived in America in 1978. She teaches Israeli folk dancing and attributes cancer survival to the love of God, Israel, and the Jewish people. (Photograph by Lionne Milton, courtesy of the *Napa Valley Register*, ZUMA.)

The five home-schooled children of Cindy and Tim Noonan are accomplished musicians and scholars who excel in mathematics, sports, singing, dancing, acting, cartooning, composing, writing, bagpipes, and more. They are a source of pride to the entire Jewish community and have twice traveled to Israel. From left to right are Michael, John, Heidi, David, and Timothy Noonan. (Courtesy of Cindy Noonan.)

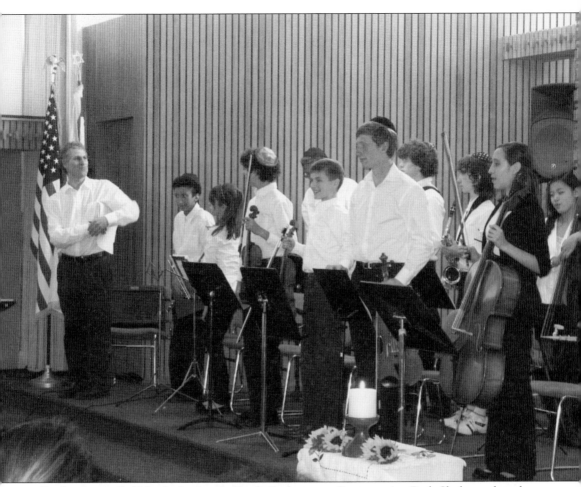

Gordon Lustig (left) leads the Jewish Youth Orchestra at Congregation Beth Sholom, where he is music director. At age 12, Gordon was music leader at Temple Beth Torah in Fremont, and by age 14, he was leading music at weekly services and holidays. At age 19, he composed "*Hine Tov M'od*," which became a standard in many Jewish camps throughout the country. After attending the Dick Grove School of Music, he composed the theme song and background music for a network television sitcom. That was followed up with seven more shows and pilots, including *Chicken Soup* with Jackie Mason. In the 1990s, he composed the music for a Jewish short-story series on National Public Radio called *One People, Many Stories*, hosted by Jerry Stiller. Gordon and his wife, Karen, a social worker, live in Napa with their two sons, Max and Oliver. Lustig plays guitar, banjo, mandolin, and trombone. (Courtesy of Lynn Michalski.)

In this c. 1980s photograph, lots of little Queen Esthers, Mordachais, and Hamans pay close attention to a Purim spiel during Sunday school at Congregation Beth Sholom. The children eagerly blot out the name of Haman, Persia's wicked minister who wanted to kill all the Jews, every time his name is mentioned in the reading of the *megilla*, which tells how Esther helped save her people in ancient times. (Courtesy of CBS.)

Bringing in a happy Purim are Groucho (Max Schleicher) and a hippie (Betsy Strauss), who lead the monthly Conservative minyan at Congregation Beth Sholom. Max has been a math professor, computer programmer, and Hebrew teacher. Betsy is an attorney and mediator specializing in local government law. She is using her master's degree in Jewish studies to help Jewish communities resolve conflict based on the traditions and teaching of Judaism. (Courtesy of Betsy Strauss.)

Toasting with both Israeli and Napa wines are members of Congregation Beth Sholom with Rabbi James Brandt (seated, center) in the Golan Heights. Held in 2007, this was the first trip to Israel for most of the multigenerational participants. It was a trip of a lifetime, including hiking and jeep trips; sightseeing and study in Caesarea, Tzfat, Masada, Tel Aviv, and Jerusalem; and a Dead Sea spa day. (Courtesy of Jo Anne Miller.)

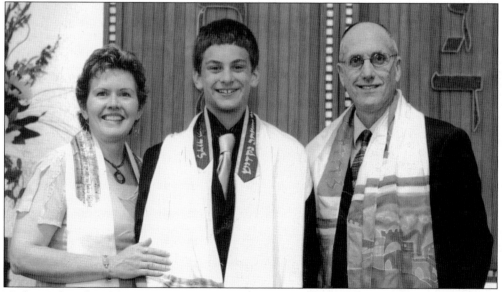

Nathan Edwards celebrates his 2007 bar mitzvah. From left to right are Cantor Bella Bogart (who is now a rabbi), Edwards, and Rabbi Kennard Lipman. Bogart, a talented musician, served at both Congregation B'nai Israel and Congregation Beth Sholom, and is now a spiritual leader in Sonoma. Rabbi Lipman studied Tibetan Buddhism for 20 years, received Reform ordination, and brought meditation, intellectualism, and scholarship to Napa. (Courtesy of Mara Blevis.)

Congregation Beth Sholom's 45th anniversary was formally celebrated in the caves of Pine Ridge Winery. For its first 45 years, CBS was an independent congregation with a part-time rabbi and no paid staff. Enjoying the evening are, from left to right, Dr. Julie Cohen, Dr. James Bronk, Dr. Jonathan Cohen, Suzanne Bronk, Debra Heaphy, Dr. Steve Veit, Dr. Joan Harris, and Jim Heaphy. (Courtesy of Kopol Bonick Studio.)

In 1998, Julie Ann Kodmur organized an effort to purchase a public menorah, soliciting funds and support from local churches and the community at large. The menorah is installed and lit every year at Lyman Park in St. Helena. Here, Charlotte Smith, daughter of Julie Ann and Stuart Smith, enjoys the festivities. Julie Ann, a marketing consultant, is active in local philanthropy, including at Congregation Beth Sholom. (Courtesy of William Craig, Craig Prographica.)

David Mendelsohn plants a tree in his mother's memory on Israel's 50th anniversary. An executive who assisted in the development of BankAmericard, he has served on many boards. He is vice president of finance at Congregation Beth Sholom and a board member of the American Israel Public Affairs Committee. He is also a SCORE counselor, helping people start their own businesses. He and his wife, Donna, received the State of Israel Bonds' 40th Anniversary Award. (Courtesy of Donna Mendelsohn.)

Almost 200 people gathered at Congregation Beth Sholom to celebrate Israel's 60th anniversary. It was a glorious evening of wine, music, noshing, Israeli dancing, and birthday cake. An original play, *This Is Your Life, Israel!*, was performed by the Sunday school. Enjoying the evening are, from left to right, Nancy and Peter Gennet, Bernard "Bunny" and Bette Goldstein, and Sandra Hyman. (Courtesy of CBS.)

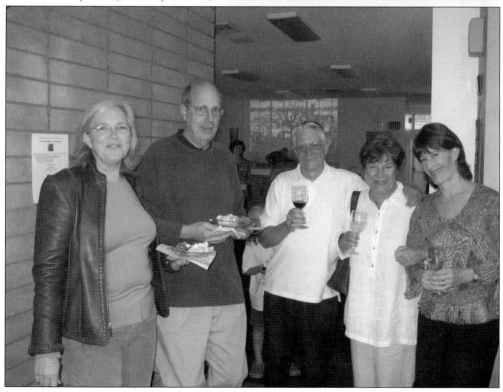

The Bonicks are, from left to right, Dona, Dylan, Max, and John. Dona and John, owners of Kopol/Bonick Studio, have photographed the people, places, and wines of Napa Valley for two decades. John is a painter who shows in galleries in San Francisco, Los Angeles, and Miami. Dylan works in the visual arts, while Max is a jazz pianist who plays flute, guitar, and mandolin. (Courtesy of Kopol Bonick Studio.)

Evy (left) and Morrie Warshawski (right) met through AZA/BBG Jewish youth groups in Kansas City, Missouri. Their parents were Holocaust survivors. The Warshawskis moved to Napa in 2004, where Evy was executive director of the Napa Valley Opera House until 2011. Morrie is a consultant who helps nonprofits with strategic planning and independent filmmakers with career development. They have two daughters, Leah and Maura (the bride). (Courtesy of Evy Warshawski.)

Flamenco dancers Leona and Jack Siadek enjoy "Oy-Olé," a 2006 Joke Night theme. Joke Night is a large fundraising event that takes in more than $20,000 annually for Congregation Beth Sholom's general fund. Jack was the mayor of El Segundo, and Leona (Egeland) served in the state assembly from 1974 to 1980. They were honored to run with the Olympic torch for the 2002 Winter Games. (Courtesy of Leona Siadek.)

Joke Night's 2008 theme was "Sports Central." Costumed athletes and sports heroes were served a gourmet salmon dinner prepared by Chef Stan Press and his crew using Art Finkelstein's famous barbecue recipe. "Referee servers" of the youth organization Yachad (Hebrew for "together"), from left to right, are (seated) Jesse Barush, Samuel Reisman, and Michael Charney; and (standing) Nathan Charney, Ariel Cohen, and David Williams. (Courtesy of CBS.)

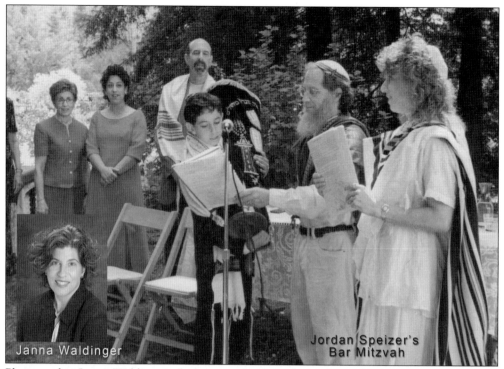

Janna Waldinger

Jordan Speizer's Bar Mitzvah

Photographer Janna Waldinger adapts prayer books to be traditional yet reflect current times. Waldinger founded Chavurat Napa in 1994 to experience new ways of engaging in Jewish life. Celebrating with Jordon Speizer (center) are (from left to right) his grandmother, Jenny Lind; Nancy Rose; and his father, Dr. Carl Speizer. Rabbi Victor Gross and Cantor Nadya Gross are at Jordon's right. The inset shows Waldinger. (Courtesy of Art and Clarity.)

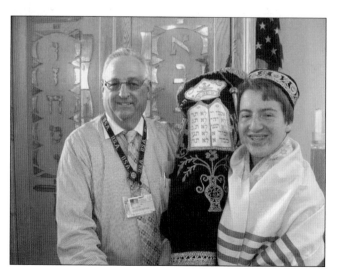

Isaac Kirkland (right) is the great-grandson of Congregation Beth Sholom's founders, Joe and May Lazarus, and the great-great grandson of Samuel and Annie Lazarus. He was the first "Son of the Covenant" sanctioned at the Veterans Home of California's Jewish chapel in Yountville. Veterans Home chaplain Rabbi Ira Book performed the ceremony. Rabbi Book served as chaplain at Folsom State Prison for years, using a portable Torah. (Courtesy of Henry Michalski.)

The Eisenberg and Gottfried families, the "Eisengott Clan," met at Tot Shabbat and share carpooling, childcare, homeschooling, and more. The kids and dog are, from left to right, (first row) Kelev (the dog), Jonah, Abi, and Ari; (second row) Leah, Micah, Hillary, and Matt; (last row) Mo, Lisa, and Louis. Matt Eisenberg is a business lawyer and creator of Playground Fantastico, and Hillary Homzie is a children's book author. Lisa Gottfried is chief executive officer of DigitalWeavers. Her husband, Louis, founded an Internet company. (Courtesy of Henry Michalski.)

Leslie Medine is the founder and executive director of On the Move, a nonprofit that builds and sustains effective leaders and healthy organizations in the public sector. She is the cofounder of VOICES Napa, a national model for empowering youth as they make the transition out of foster care. (Courtesy of Leslie Medine.)

San Franciscan Alexis Handelman came to Napa in 1982 with her winemaking husband and son, Andrew. She has always loved baking, and soon friends and businesses were clamoring for her tasty delights. Alexis Baking Company, which employs 24 people, is a popular bakery, restaurant, caterer, and meeting place that recently celebrated its 25th anniversary. Blum's-style coffee crunch cake and round challah are popular items. (Courtesy of Henry Michalski.)

Reuben Katz's life started in Pittsburgh's Jewish Squirrel Hill area. After earning a master's degree in economics, he worked at the Rainbow Room in Manhattan and the Culinary Institute of America at Hyde Park, which led him to St. Helena's CIA at Greystone. Reuben serves on the Napa Valley College Foundation board and works with other civic organizations. He served on the American Institute of Wine & Food board. (Courtesy of Reuben Katz.)

Piatti cofounder and Restaurant Hall of Fame member Claude Rouas is shown with his daughter, Bettina. Trained as a chef in Paris, she returned to Napa Valley and honed her skills at the French Laundry, Bistro Jeanty, and Bistro Don Giovanni. In partnership with sister Claudia and her father, she opened Angèle Restaurant & Bar on Napa's riverfront, named for Rouas's mother. (Courtesy of Claude Rouas.)

Restaurateur and restaurant consultant Michael Dellar, of Fish Story Napa River and Lark Creek Restaurant Group, and floral designer Leslye Dellar have made Napa Valley their home since 2002. Their cabernet sauvignon vineyard produces Stardust, and community activities and directorships have included the Anti-Defamation League, the Jewish Community Foundation, the Napa schools, COPIA, the Napa Valley Destination Council, and the Make-A-Wish Foundation. They are members of Congregation Beth Sholom. (Courtesy of Leslye and Michael Dellar.)

Born in Baltimore and graduating from the University of California, Los Angeles, and Harvard University, Charles Slutzkin's 40-year career in engineering, construction, and real estate development culminated in the 320-acre Napa Valley Gateway Business Park. Located near the Napa County Airport, it is the largest business park in Napa County. Slutzkin is founder and president of the Napa Valley Corporate Champions for Childcare. (Courtesy of Charles Slutzkin.)

Steve Carlin, musician and songwriter, also discovered a passion for food. In 1980, he ran the wine department at Oakville Grocery Company and within a few years became a partner in its stores. Receiving a call from the San Francisco Ferry Building, he was hired as redevelopment project director. From there, he developed the Oxbow Public Market, which today boasts two dozen tenants in over 30,000 square feet of retail space. (Courtesy of Jim White.)

As a founder and general partner of Rogal + Walsh + Mol, Ivy League–educated Keith Rogal brings 20 years of experience to the development of residential, hospitality, and mixed-use real estate. Keith is the creator of the award-winning Carneros Inn, a 27-acre resort project comprised of 96 cottage hotel units, two restaurants, a spa, and various amenities. He is currently engaged in the development of a 150-acre, mixed-use site on the Napa River. Rogal has extensive experience working with luxury hotels and resorts, and has a strong network of contacts in hotel, airline, and events planning and related areas in more than 30 countries. Throughout his career, Rogal's professional activity, both as developer and advisor, has focused on the creative reuse of previously developed sites. His work is guided by the principles of the charter of the Congress for the New Urbanism, to which he was a signatory. (Courtesy of Keith Rogal.)

Lisa Cort (left), Tracy Schuler (right), David Goldman, and Barry Schuler established Blue Oak School, a private school that opened in 2002 to provide children with a progressive education. Housed in a renovated historic building, it now serves students in kindergarten through fifth grade. A middle school (grades six through eight) was built in 2005, several blocks away. (Courtesy of Blue Oak School.)

Prior to moving to Napa Valley and rekindling his youthful passions for radio, journalism, and public affairs, Yale University graduate Jeff Schechtman was involved in all phases of independent motion-picture production in Los Angeles. Raised in New York, Jeffrey has served as general manager of KVON/KVYN since 2003. He hosts KVON's *Late Mornings*, on which he has interviewed over 7,000 of the most imaginative thinkers and leaders of our time. (Courtesy of Henry Michalski.)

"Our honey is certified kosher because our bees get buzz-mitzvahed," jokes Helene Marshall, who, with her husband, Spencer, established Marshall's Farm Honey in American Canyon. The Marshalls practice an artisanal, handcrafted approach to traditional honey production. At their secluded farm, sweet delights await eager customers, including gift baskets, *l'chaim* honey straws for Rosh Hashanah, and HoneyKah gifts for Chanukah. (Courtesy of Henry Michalski.)

Working professionally in radio, television, modeling, and theater since childhood, Evonne Alumbaugh was prepared to direct *Deathtrap* at the local Dreamweavers Theater at age 87. She and her husband, Norman, have owned and decorated three Eagle and Rose hotels and run a 160-acre vineyard in Pope Valley, bottling 5,000 cases of their Eagle and Rose wine annually. Evonne served on Napa County's Grand Jury and was an ambassador for the St. Helena Chamber of Commerce. (Courtesy of Evonne Alumbaugh.)

The second b'not mitzvah event in Congregation Beth Sholom's history took place in 2009 when five women led an emotional, spiritually uplifting service to a packed house. Ranging in age from 54 to 85, the five women are, from left to right, Audrey Lieberstein, Bunnie Finkelstein, Sue Barush, Kathleen Conrey, and Louise Packard. Several had not had any Jewish training as children and embraced Judaism later in life. (Courtesy of CBS.)

In a rite of passage usually reserved for 13 year olds, three women completed b'not mitzvah in the third such ceremony at CBS in 2010. A beaming Belle Altman, Zoe Kahn, and Rachel Friedman—all active members of the Jewish community—are shown wrapped in their new *tallitot* (prayer shawls), after several years of study that included Hebrew language and trope. (Courtesy of CBS.)

Congregation Beth Sholom Presidents

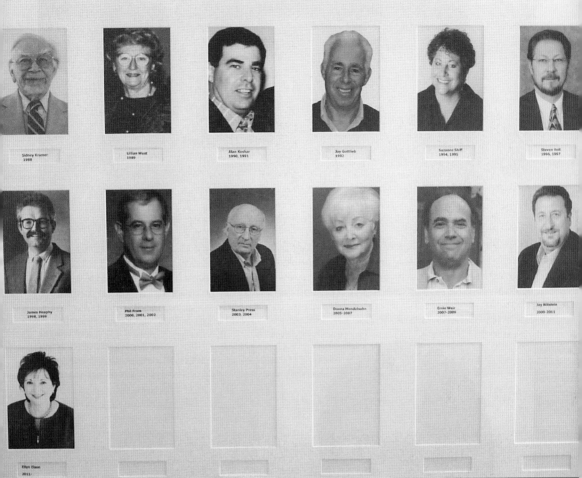

From 1988 to the present, leadership has been distinctly different at Congregation Beth Sholom. Women began assuming the synagogue's presidency. Fear of anti-Semitism, which had concerned many early members, gave way to pride of being Jewish. The synagogue experienced different types of Judaism, from the Reconstructionism of Rabbi David Kopstein, to the Conservativism of Rabbi David White, to becoming Reform in 2003 with the first full-time Rabbi James Brandt. CBS presidents are, from left to right, Sydney Kramer (1988), Lillian West (1989), Alan Koshar (1990–1991), Jay Gottlieb (1992), Suzanne Shiff (1994–1995), Steve Veit (1996–1997), Jim Heaphy (1998–1999), Phil Fram (2000–2002), Stan Press (2003–2005), Donna Mendelsohn (2005–2007), Ernie Weir (2007–2009), Jay Blitstein (2009–2011), and Ellyn Elson (2011–present). In June 2011, under the dynamic leadership of Ellyn Elson, the congregation officially became "Congregation Beth Shalom (modern spelling) of Napa Valley, a Community Jewish Center." CBS is anticipating a major building remodel and is participating in the first Jewish community cemetery in Napa County, Ner Tamid, at St. Helena Cemetery. In 2012, Rabbi Lee Bycel was engaged as the synagogue's rabbi. (Courtesy of Lynn Michalski)

Karen (far left) and Steven (far right) Sager hosted the "gifted classical musicians" of the Israel Defense Forces in their home. The Jewish Historical Society of Napa Valley sponsored the charity concert. Brig. Gen. Nehemia Dagan explained the special IDF program that promotes the musical talents of its young soldiers. The musicians performed classical standards and Israeli favorites. (Courtesy of Kopol Bonick Studio.)

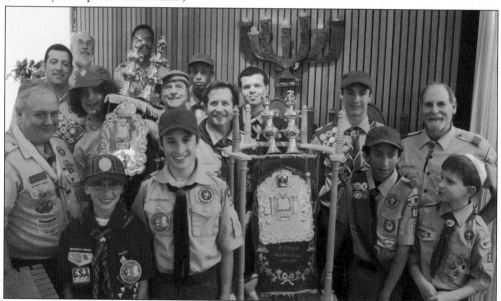

The connection between Judaism and scouting culminated in a Scout Shabbat. Left to right are (first row) Dominic De Pasqua, Jacob Edwards, Jonah Thornton, and Jacob Sousa; (second row) Shofar Award recipient John Hagan, Ben Barush, Peter Di Pasqua, Eagle Scout Timothy Noonan, and Roy Barush; (third row) Eagle Scout Ben Pastcan, Alan Koslofsky, and Eagle Scout Kevin Hagan; and (back row) Thomas Sabo, Aaron Thornton, and Eagle Scout Joshua Thornton. Absent from the photo are Eagle Scouts Jesse Barush, Jacob Engleskirger, David and Jason Hagan, Samuel Sabo, and Silverado regional chairwoman Jonnie Hagan. (Courtesy of Lauran Posner.)

The Table is a feeding program for Napa's needy. Congregation Beth Sholom was one of the founding members over 20 years ago when the late Dorthee Hauser Braid got the congregation involved. The synagogue has played a vital role in *Tikkun Olam* by providing 150 to 225 nutritious meals at the First Presbyterian Church in downtown Napa every fourth Monday. Early coordinators were Paula Fields, Elizabeth Mautner, Pamela Bernstein, and most recently Rhonda Simon. Pictured here, from left to right, are (first row) Rachel Friedman, Bette Goldstein, Donna Mendelsohn, Harriet Spitz, and Alan Steen; (second row) Anne Percelay, Debbie Percelay, Rhonda Simon, and Bunnie Finkelstein; (third row) Martha Pastcan, Steve Veit, and Rivka Livni. Other dedicated volunteers are Pamela Bernstein, Tucker Catlin, Sandi Hyman, Richard Pastcan, Ada Press, Minnie Shostak, Bob Simmerman, Joshua Slater, and Charlene Steen. Many congregants donate funds for the freshly prepared food. Known by their clients as the "Jewish Women Who Cook," the group is also praised as serving the "best Table meal in town." (Courtesy of Henry Michalski.)

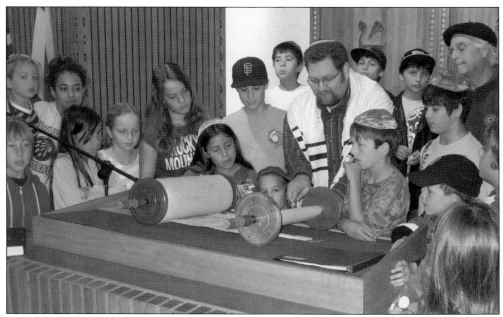

Dan Eisner (center, wearing a *tallit*) is director of education at Congregation Beth Sholom. Eisner is a fourth-generation Californian whose great-grandmother was born in San Francisco in 1898. He was born and raised in Walnut Creek and received his undergraduate degree from the University of California, Los Angeles, and his master's degree at the American Jewish University in Los Angeles. (Courtesy of Henry Michalski.)

The Jewish Historical Society of Napa Valley was formed in 2002 as a cultural and educational organization whose goal is to tell the important and often forgotten stories of the Jews of Napa Valley. Leaders of the organization, pictured planning programs and events, are, from left to right, Lynn Michalski, Donna Mendelsohn, Lauren Chevlen, Phyllis Kleid, and Zoe Kahn. Also instrumental was the late Louise Packard. (Courtesy of JHSNV.)

BIBLIOGRAPHY

Adams, I. C. *Memoirs and Anecdotes of Early Calistoga*, Calistoga, CA: self-published, 1946.

Dinkelspiel, Frances. *Towers of Gold: How One Jewish Immigrant Named Isaias Hellman Created California*. New York: St. Martin's Press, 2008.

Harroun, Catherine, and Ruth Teiser. *Winemaking in California*. New York: McGraw-Hill, 1983.

Heintz, William F. *Wine Country: A History of Napa Valley, The Early Years: 1838–1920*. Santa Barbara, CA: Capra Press, 1990.

———. *California's Napa Valley: One Hundred Sixty Years of Wine Making*. San Francisco: Scottswall Associates, 1999.

Levinson, Robert E. *The Jews in the California Gold Rush*. Berkeley, CA: Commission for the Preservation of Pioneer Jewish Cemeteries and Landmarks of the Judah L. Magnes Museum, 1994.

Palmer, Lyman L. *History of Napa and Lake Counties, California*. San Francisco: Slocum, Bowen and Company, 1881.

Peninou, Ernest P., and Gail G. Unzelman. *The California Wine Association and Its Member Wineries, 1894–1920*. Santa Rosa, CA: Nomis Press, 2000.

Rochlin, Fred and Harriet. *Pioneer Jews: A New Life in the Far West*. New York: Houghton Mifflin Company, 2000.

Rosenbaum, Fred. *Cosmopolitans: A Social and Cultural History of the Jews of the San Francisco Bay Area*. Berkeley, CA: University of California Press, 2009.

Sullivan, Charles L. *A Companion to California Wine*. Berkeley, CA: University of California Press, 1998.

———. *Napa Wine: A History from Mission Days to Present*. San Francisco: Wine Appreciation Guild, 1994.

Teiser, Ruth. *Alfred Fromm: Marketing California Wine and Brandy*. Regents of University of California, 1984.

Voorsanger, A. W., and Martin A. Meyer, ed. *Western Jewry: An Account of the Achievements of the Jews and Judaism in California*. San Francisco: Emanu-El, 1916.

Weber, Lin. *Under the Vine and the Fig Tree: The Jews of the Napa Valley*. St. Helena, CA: Wine Ventures Publishing, 2003.

DISCOVER THOUSANDS OF LOCAL HISTORY BOOKS FEATURING MILLIONS OF VINTAGE IMAGES

Arcadia Publishing, the leading local history publisher in the United States, is committed to making history accessible and meaningful through publishing books that celebrate and preserve the heritage of America's people and places.

Find more books like this at
www.arcadiapublishing.com

Search for your hometown history, your old stomping grounds, and even your favorite sports team.